Sony
A300/A350

Focal Digital Camera Guides

Sony
A300/A350

Shawn Barnett

ELSEVIER

AMSTERDAM • BOSTON • HEIDELBERG • LONDON
NEW YORK • OXFORD • PARIS • SAN DIEGO
SAN FRANCISCO • SINGAPORE • SYDNEY • TOKYO

Focal Press is an imprint of Elsevier

Focal
Press

Focal Press is an Imprint of Elsevier
30 Corporate Drive, Suite 400, Burlington, MA 01803, USA
Linacre House, Jordan Hill, Oxford OX2 8DP, UK

Recognizing the importance of preserving what has been written, Elsevier prints its
books on acid-free paper whenever possible.

Library of Congress Cataloging-in-Publication Data
Barnett, Shawn.
 Sony A300/A350 / Shawn Barnett.
 p. cm. — (Focal digital camera guides)
 Includes index.
 ISBN 978-0-240-81143-7 (pbk. : alk. paper) 1. Sony cameras—Handbooks, manuals, etc.
2. Photography—Digital techniques—Handbooks, manuals, etc. I. Title.
 TR263.S66B373 2009
 771.3'3—dc22
 2008032529

British Library Cataloguing-in-Publication Data
A catalogue record for this book is available from the British Library.

ISBN: 978-0-240-81143-7

For information on all Focal Press publications
visit our website at www.books.elsevier.com

08 09 10 11 12 5 4 3 2 1

Typeset by Charon Tec Ltd., A Macmillan Company. (www.macmillansolutions.com)

Printed in China

Table of Contents

Introduction	1
Breaking Down the Mysteries	3
Quick Start	5
First Principles	13
Visual Tour	21
Part 1: The Camera	**23**
Section A: Record Modes	25
Section B: Viewing the Images	55
Section C: Menus	61
Section D: Memory Cards, Batteries and Maintenance	79
Part 2: The Software	**87**
Sony Software	89
Sorting and Storing Your Images	99
Backing Up	101
Part 3: The Light	**103**
Using Natural Light for Effective Pictures	105
Part 4: The Lenses	**119**
Introduction	121
Conversion Factor	123
Choosing a Lens	125
Wide-angle Lenses	129
Standard Lenses	133
Telephoto Lenses	137
Close-up Lenses	141
Part 5: The Subjects	**143**
Portraits and People	145
Kids and Pets	151
Travel	155
Action	161

Part 6: Accessories **165**

Introduction 167
Flash 169
Tripods 175
Remote Controller 183
Battery Grip 185
Printer 187

Glossary 191
Links 197
Index 199

Most people think of single-lens reflex cameras (SLRs) as complicated cameras that only gadget geeks and professional photographers know how to use. Nothing could be further from the truth. There was a time when using an SLR meant that you had to learn a lot of unfamiliar terms and think about so many factors that you would get very few photos at all, and frequently the pictures that you got back from the photo lab were not very good.

Fast forward twenty-five years from the first autoexposure systems to today, when we have digital SLRs that can automatically set exposure and focus, and carefully analyze the light in a scene to make sure that all the colors are right. Even better: the digital revolution means that you don't have to shoot a whole roll and drive down to the store to have your photos developed for a fee just to see if you're turning all the right dials and pressing the right buttons. Instead, you can see each photo right on the back of the camera, immediately after you press the shutter button. Digital photography is more economical in several ways, such as saving on gas and development costs, but more importantly for our purposes, digital photography saves time.

This book is designed to serve not as a manual replacement, but as a guide to using your camera to its fullest. You'll learn about basic functions and settings, and also how to compose images in a number of common situations. I shot example photos that are easy to emulate with inexpensive materials, simple techniques, and just a little practice.

Entering a new world. Exposure: f/5, 1/250, ISO 400.

My hope for this book is that it will start a fire. That may be a grand hope for a simple camera guide, but if you embrace only half of what is presented in this book, the fire will burn in your heart as a deep passion for photography.

On a recent trip to an amusement park, I saw more digital SLRs than ever hanging around the necks of my fellow tourists. It was entertaining to see just what brand and what lens each person had. I saw mostly smaller SLRs, including the Sony A100, a few bigger ones, and a few guys carrying ridiculously large professional zoom lenses. I may have envied them their ownership of such high-quality expensive glass, but I certainly didn't envy their necks and back.

A student of human behavior, I also noticed something unusual. Although I saw a lot of people taking snapshots with their digital SLRs, it was the Sony A100 and A700 owners who were leaning forward, crouching down, and trying a new approach to get a different angle as they brought their digital SLR to their eye. They weren't just taking obvious pictures—they were looking to make new photographic opportunities with their digital camera. I was impressed.

I hope this book helps foster the kind of photographic ambition in you that I saw in our fellow Sony SLR owners.

The Minolta camera line from which the Sony Alpha line descends has many devotees, and for good reason. Called the Minolta Maxxum in the United States, Dynaxx in Europe and abroad, and Alpha in Japan, this line of cameras has a reputation for quality, innovation, and excellent optics. All three of those qualities live on in your Sony A300 or A350.

After just a few short chapters, I hope you'll come away with not only a new appreciation for your camera, but also a new appreciation for the art of photography.

Quick Start

Getting to know your Sony Alpha

You've already taken the first steps toward getting to know your Sony Alpha better by buying and starting to read this book. But I'd like for you to start getting to know your camera for real, including its strengths and limitations. There's no better way to do that than to take a lot of pictures.

You bought this book so that I could help you learn to use your new digital camera both quickly and thoroughly, and the most helpful tool at my disposal is your new Sony digital SLR itself. Minolta and Sony have spent years developing cameras that can make photography easy, and for the most part your Sony A300/A350 will deliver excellent snapshots with a few easy steps. You may decide that it takes such good shots in full Auto mode that you don't need to know any more. But I'm sure that if you do what I ask, you'll discover two truths: that the last thirty-five years of camera innovation have done a lot to ensure good pictures in full automatic mode, and that there's still a lot you can learn about the other modes on your camera to make your snapshots into something you're more likely to proudly refer to as "photographs." Note: The following is for first-time digital SLR users. If you're more experienced with digital SLRs, feel free to skip to the next chapter.

Turn on power and Super SteadyShot.

Ready? Okay, turn your Sony digital SLR on by flipping the switch on the upper left of the camera's back. Verify that the Super SteadyShot switch on the lower right is set to "On."

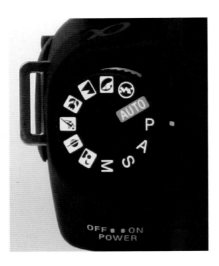

Mode dial.

Next, turn the mode dial on the left side of the top deck to the green "Auto" setting.

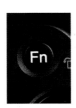
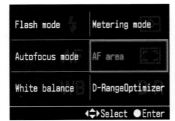
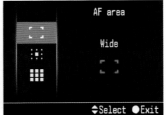

Function Button.

Now press the Function button on the back and use the Controller disk to navigate to AF Area and use the up or down arrows to change the focus setting to Wide, if it's not already selected.

Got it? Excellent.

Now, take off the lens cap and get ready to take some pictures. I've taken a few of the same pictures I suggest here to give you an idea. They are all taken in full Auto mode with the same settings that I've called for.

Don't get up yet. Start where you're sitting. Put the camera up to your eye and point it at a nearby lamp (if you're not near a lamp that you can turn off and on, change rooms). Most likely, your Sony Alpha SLR sprang into action the moment you raised it to your eye, setting focus before you even got comfortable looking through the viewfinder.

This is a Sony innovation unique to the Alpha line, so now is a good time to feel proud that you bought such a cool camera.

Here are my lamp shots: Window light, flash on, flash off with the incandescent light on.

Now put your finger on the shutter release button, high on the top of the grip, and press it halfway. You'll hear a double beep, and one of the autofocus points in the viewfinder will light up red. Now, press the shutter button all the way. You've just taken your first picture, so look at the back of the LCD. Take note of how it looks, then return the camera to your eye.

Grab the big rubber grip toward the front of the lens, which is called the zoom ring, and turn it left and right. Look through the viewfinder and do it again. This should change your view from wide angle and move toward telephoto. Take a few more pictures at different zoom settings.

I don't want you to think a lot about composition unless you already know a thing or two. We'll talk about that later. I just want you to try the basic controls on your Sony Alpha and get the feel of the camera. Remember, it's digital, so you're not wasting film. Before you get up, take a few more pictures of that lamp. If it's off, turn it on. If on, turn it off. I want you to look at each picture on the LCD after you capture it and listen to the camera as you shoot.

Now, pop up the flash. You activate it by pressing the release button to the left of the front lens housing. Take a few more shots of the lamp, both on and off. Get up and move around the room. Point your camera at a few interesting objects, some near, some far. Take some pictures, again, both with and without flash (to deactivate the flash, just push it back down).

Note how the Sony A300/A350 focuses. Press the shutter release halfway several times before taking a shot. Does the camera pick the same autofocus point every time? Probably not. Try a few different subjects and you'll see what I mean.

In full Auto mode, the camera chose f/5.6 and 1/25 second. The camera's Super SteadyShot handled the slow shutter speed, but the resulting wide open aperture left everything but the middle vehicle out of focus.

If it's fairly dark indoors, as it usually is, how long does it take before the shutter closes and the camera displays an image? Are you able to get a sharp shot, or is it blurry?

Weather permitting, go outside into brighter light. Does the camera sound different? The shutter should sound a lot faster than it did indoors, and you should have fewer fuzzy pictures. Take a picture of your car or another vehicle at a wide angle. Zoom in to telephoto and take a shot of a headlight. Now pop up the flash and take the same two shots. Notice anything different?

Again, watch where the camera is focusing—it's probably not the same every time.

Are there any people around? Go get one. Offer to take his or her picture. Be bold. Offer your subject a free print—once you figure out how to do that. We'll talk more about boldness in the Portraits section, when we go over making your model feel comfortable, but telling them that you're just learning how to use your new camera should set them at ease.

Assuming that you've persuaded your subject, I want you to set your camera all the way to telephoto. If you're using the kit lens, just turn the zoom ring all the way to the right until the number 70 lines up with the white notch on the lens body. Stand back about six to seven feet. Take several pictures at this setting, changing from horizontal to vertical and back. Move around a little.

The camera chose f/10, 1/125 second at ISO 100, and it fired the flash, because I had it up. This small aperture left the background a little more in-focus than I like.

Taken near sunset, these images are a little yellow, or golden; this one is a little more so than some of the others.

I popped up the flash for this shot to fill in the shadow created by the backlight. While the sunlight is yellow, the flash is a little blue. Note the lens flare that starts in the upper-right corner, dimming some of the image's contrast.

Then turn the zoom ring to 18, which is wide angle. Get some head-to-toe shots if you can, then get in closer. Get right up to their nose. When does the camera stop focusing? It should be about seven inches.

Look at the light. If your model is very cooperative, face him or her into the sun and take a few shots with and without flash, then shoot with the sun at his or her back with and without flash. Shoot your subject some more with the sun lighting up one side, then the other; again, try the flash, then turn it off. Then move the person into a full shadow setting, like the side of a building in shade. Shoot some more shots without flash, then pop up that flash and take some more shots.

Experiment. Go crazy. Shoot flowers, cats, dogs, fire hydrants, trees, vistas, and houses.

Try out the tilting LCD. Shoot from high over your head, shoot from low down on the ground. It's amazing how different your pictures look when you change the vantage point, and your Sony A300 or A350 can help you frame from unique angles, especially down low, without getting leaves in your hair, or activating your trick knee.

When you've filled up the card, head back inside and copy them to your computer. If you haven't set up your computer to receive pictures from your camera, we can do what you need right on the back of the camera, thanks to that big, beautiful display; or just slip the camera's software CD into your computer and follow the instructions.

Now let's look at your images. If you're going to look on your camera, just press the Playback button, which should be the button next to the lower-left corner of the LCD. You should see the last picture you took. Scroll right to select the first image you shot.

Starting with the shots of the lamp (if you followed my directions and had a lamp handy), you should notice a few things right away. From shot to shot, you might find that different parts of the photo are in focus. Sometimes the shade, sometimes the table or pole, and sometimes even the background might be in better focus than the lamp itself. You might also find that the shots with the lamp on and off have a very different color to them, and you might see that depending on whether you were zoomed in or out, the overall color may also have changed a little. The images with the lamp on might also be sharper than the images with the lamp off, and the images with the flash on are probably sharper still.

You've just discovered that as advanced as this camera is, it doesn't always choose the same point of focus. It also sees light very differently from how you and I do. We usually see most light sources as white, while the camera sees incandescent light bulbs as a lot more yellow; other types of light can appear blue, red, or even green. The Sony Alpha's Auto White Balance tries to pick the right setting, but sometimes fails. Finally, you learned that the camera takes blurry shots if you don't give it enough light to work with. The auto-focus system struggles to focus in low light, the shutter stays open too long in low light, and wide apertures leave much of the image out of focus. All three circumstances result in blurry images. Don't worry; there are good solutions to most of these problems. But I wanted you to discover the problems for yourself.

Next, let's look at the vehicle shots. Where did the autofocus system set the sharpest focus? Was it always the same? Was it most often the part of the car that was closest to the camera? Or was it a part of the car with more contrast? Does the car's nose look disproportionately bigger in the wide-angle shots? How about the close-ups of the headlight? Is that in focus? Is there anything different about the flash shots? Does it look like the running lights are on? Interesting. What about the shadows on the sides and in the wheel wells—do they look different?

Again, the autofocus system works better when it has some contrast to work with, and cars are very often big shiny monochrome blobs with little contrast over large parts of their surface. Sometimes the surfaces can be so reflective that the camera focuses on a reflection in the window or paint, not the car itself.

At a wide angle, you should notice some distortion, where the closest part of the car seems a lot bigger than the rest of the car. This effect can improve or hurt a photo, depending on what you're trying to portray. Cars are also big enough that fill flash can really help show up some hidden beauty, lighting up both paint and reflectors. It can also reveal some ugly dirt, like in the wheel wells. Flash tells both big lies and stark truths, and you can learn to use this dual nature to your advantage, depending on the story you want to tell.

Finally we get to the people pictures. These are my favorites. It's easier to shoot inanimate objects, but when you learn to photograph living creatures, there's nothing more rewarding. Because the human face in particular is capable of so many expressions, there's a rich palate of colors with which to paint portraits once we learn to work with people.

Shoot first at telephoto range. This is generally the best focal length for flattering portraits; somewhere between 60mm and 140mm with the Sony A300/A350. You should also find that your vertical shots are a little more interesting than the horizontal ones.

People are vertical, and you keep them as the main subject when you fill the frame with mostly person. The exception, of course, is when you're trying to show more of their setting. Changing positions and looking at the background can do a lot to help portray your subject. Of course, zooming to a wide angle does a lot to include the person's setting as well. Include their feet, because if you give people a place to stand, the photo gets a lot more comfortable to look at than if they're cut off at the ankles. You might have to step back for this, but you'll be surprised how much just taking a single step in the right direction can improve your pictures.

Of course, when you got close, the distortion took over again, and very likely made people's noses look gigantic, or their foreheads; whatever part you had closer to the lens. If you want to have real fun, get very close and tilt down to include their feet: funny face on a stick. Now look again at those telephoto portraits. Quite a difference, eh? This is an important lesson, because too many early photographers take pictures of people at a wide angle.

Shooting with the sun facing your subjects, you should have noticed that their faces are pretty washed out. If it was close to noon, their eyes are probably dark sockets, and their skin is probably blown out (meaning white, with no color in them) in places. They're also squinting, no doubt. If you took some flash shots in this lighting, you'll probably find that those eye sockets have more detail in them. You might even be able to see the color of their eyes compared to the dark muddiness of the non-flash shots, but the squinting is surely still a problem. The shots with the sun at their backs are probably not squinty, but their faces are underexposed (meaning dark). The flash shots should be much better, once again. Surprising, isn't it, that flash is so helpful when

Shooting people at a wide angle close up is not a great idea, unless you're trying to be funny.

Moving my subject into the shade changed everything. The light is much cooler, better matching the flash. It was too late in the day to use a reflector, unfortunately.

you're in broad daylight? Though you don't want to use it all the time, flash can very often help in a pinch. I actually use mine more outdoors than in.

You should have gotten your best shots in the shade, believe it or not, provided that your background wasn't backlit. I try to find places where there are white walls nearby that are fully lit by the sun, so they can reflect into the shadows and illuminate my subject. This is easier in the late morning or mid-afternoon. Or I bring my own reflectors and lighting. Here, also, flash shots might have helped, but I'm willing to bet that if the surrounding light was bright enough, the flash shots won't be your best. Though on-camera flash is most often used in low light, it's usually a poor substitute for light from a more natural source. Here in the shade your subjects are also more comfortable. They're not squinting and the light can be surprisingly even and flattering. Auto white balance, unfortunately, doesn't always change to match the light, so the lighting might look colder than you expected.

If your memory card was a big one, you have a lot of other shots to look at. Skim through these and see what you like and don't like. Look at shadows. Are they darker than you remember? Look at the bright areas. Is there any detail, or is it all blown out? How about vibrant red flowers or red cars? Is there detail in those colors, or is it all red with little texture and shading? How about your shots that include the sky? Is the sky blue in all of them, or white? Bottom line: do all these photos look like you thought they would? Like they did to your eyes? Chances are, the answer is no, not all of them.

Is there something wrong with your camera? Not at all. Is it you? No, certainly not. But there is something you can do about it by learning more about the controls built into your camera. And thanks to digital technology, you can learn to do it as you take pictures, so that your final results are far better than what you just shot in Auto mode. We have a lot to cover, so let's get started.

First Principles

So now you have a nice digital SLR camera. It looks great, and you look great holding it. Does that guarantee that you'll get great images? Unfortunately, no; that little detail is up to us. I've given you a few tips in the last section already; here I'll go over the basics.

Understanding Aperture and Shutter Speed

Larger apertures (the lower numbers like f/1.8, 2.8, and 3.5) decrease the depth of field, making most of the image out of focus, and smaller apertures (the higher, larger numbers like f/11, 16, and 22) increase the depth of field, meaning that more of the image will be in focus. An odd consequence with some lenses is that they also get softer or blurrier overall as you move into smaller apertures, usually from f/11 and up, so you have to keep that in mind when seeking maximum sharpness. Shooting "wide open" (that is, setting the lens to its largest aperture, or f/3.5 on the Sony A300) can often result in a razor-thin plane of focus, putting the tip of the nose in focus, but leaving the eyes way out of focus. For greatest sharpness with most lenses, you want to shoot with the aperture somewhere in the middle of these extremes, like f/5.6, f/8, or f/11, depending on the lens.

Depth of field increases as you stop down the aperture. In these shots, the aperture goes from f/2.8 to f/5.6 to f/9.

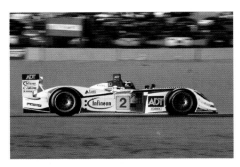

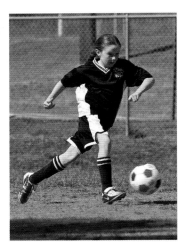

Use slower shutter speeds to blur the background while panning after a subject, as with the car, captured at f/18 and 1/250 second at ISO 200 (normally you would use a slower shutter speed for panning, but this car is very fast). Use faster shutter speeds to freeze action, as with the soccer player, shot at f/6.3, 1/500 second at ISO 100.

Faster shutter speeds freeze action, but let in less light, so you often have to use wider apertures to get the shot. Conversely, slower shutter speeds let in more light, so you often have to stop down the aperture to make up for the difference. Slower shutter speeds can cause unwanted blur in images from camera shake, but slower shutter speeds can also convey motion when you pan the camera to follow a moving subject.

How to hold your camera

A lot of people have learned to hold their small digital cameras with one hand, because they weigh so little. When presented with a camera with such a large grip as the Sony A300/A350, they think that the old method will work even better. But you'll shoot photos that are a lot more stable if you learn to hold your camera with two hands and brace your arms against your chest.

How not to hold your camera: don't shoot one-handed. Having another hand on the camera is better, but not enough.

Getting a grip

First place your hand firmly on the grip. How you achieve this depends on your hand size. I have to lock my fingertips around the outside of the grip and drop the heel of my hand down so that my thumb's in the right position for a good, comfortable hold. Then cup your hand under the lens as well as you can. On such a small camera, it can be tough to have both hands so close, but it's certainly possible. Your left palm should hold the left side of the camera's bottom, and your fingers should be up around the barrel.

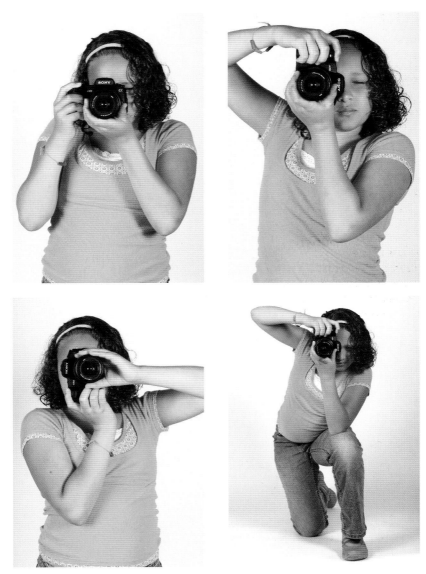

A few correct ways to hold your camera: always have your left hand on the lens, either cupping the base of the camera with your palm and reaching your fingers out to the zoom and focus rings, or clasping the lens body itself in vertical modes. Ultimately, do what is both comfortable and effective in getting a firm grip on the camera.

Taking a stand

Place your dominant foot behind you, at a slight angle, and plant your other foot forward. Pull the camera in toward your eye and bring your elbows in to rest on your body. Take a slow breath, let it out halfway, and slowly squeeze the shutter button. It should surprise you when it goes off if you've squeezed it just right. Note that bringing your arms in can help, or it can magnify your breathing and heartbeat. It differs by individual, so try both a loose arm hold and a tighter bracing against the chest to see which position delivers sharper images.

If you're shooting vertical (as I encourage you to do), I think you gain greater stability by turning the camera to the right and letting the weight rest in your hand while your elbow leans into your body. If you're kneeling, however, you can hold the lens barrel with your left hand and bring your right hand up and over. I actually switch off when I get tired in one position, so think about what will help you make the most stable shots in the situation in which you find yourself. You'll come up with other methods of holding your digital SLR, but these should get you started.

Also, when shooting in Live View mode, it's important to consider that you're not likely to hold your camera with as firm a grip as you can when pressing the viewfinder to your face. You take away one point of control—your face—when you hold the camera out from your body. Be sure Super SteadyShot is on, and brace the camera as well as you can, biasing your exposures for faster shutter speeds. Though Live View is great for those hard-to-get shots, your best, sharpest exposures will likely be made with your eye pressed against the optical viewfinder.

Most folks use a camera strap to hold their cameras when walking around. There's nothing wrong with that, and if it helps you, please attach it and leave it there. I know lots of photographers who prefer a wrist strap. I'm all for those too, just do what works for you. I use a firm grip, a camera bag, and my memory, because I can't stand camera straps. I still use them at amusement parks when I have no other option, but they bug me the whole time. There are also holsters, waist packs, backpacks, and shoulder bags, which offer a little more protection when walking around.

Don't be a masher

If you haven't heard the term "prefocus," let me introduce it to you now. So many new and inexperienced photographers blur their images and get frustrated with their cameras because when they're ready to take the picture, they just mash down on the shutter release button. I call them mashers, and their "technique" almost always results in blurry images. They expect the camera to set focus and exposure quickly, as well as make up for their camera-twisting tendencies, and are frustrated by most cameras when it takes a long time to capture their image. They get downright angry if it takes a long time and is also blurry. But experienced photographers prefocus and get better results.

To prefocus, lightly press the shutter release. You should meet some resistance at about the halfway point, which is why they also call this "half-pressing" the shutter release. I often prefocus several times before taking a shot to make sure that the AF is focusing where I want. Then I press the shutter release the rest of the way. This creates significantly less shutter lag, and makes it easier to get a shot without the motion blur that plagues the mashers.

Avoid the dead center

Every time I hand a camera to a stranger to take my picture, I'm sure of one thing: my head will end up at the dead center of that frame, instead of the well-composed image I'd imagined. There will be nothing but sky above, split by the horizon, and a wide expanse all around—but my feet will nonetheless be cut off. The only good thing that will come of it is that my face will be in focus, because they'll center their composition on the center autofocus point. If I'm lucky, they won't zoom out from where I had it set, but that usually happens too.

When you bring the camera to your eye to take a picture, you're taking a small slice of the visible world, so if you want a good picture, you need to think about what you include in that slice. Use your zoom lens to include, or better yet to cut out the parts of that surrounding world that you don't want in your picture. Often wide angle is great for catching a lot of things happening at once, but more often you want your pictures to be simple, with as little background clutter as possible. Figure out what your subject is and cut out the rest.

The rule of thirds

Placing your subject one third of the way into the frame is a good basic rule of composition. In this case, the subject is the boy's eyes. It very often gives your subject somewhere to look, or to proceed; in this case, further down the slide. It also establishes a larger, but still controlled setting for your subject to exist.

Use your mental map and divide your image into thirds, both horizontally and vertically. You can do this with many famous photographs, and you'll find that many photographers place their main subject at one of the four points where these lines intersect. Whether you're shooting horizontal or vertical, photos with subjects that land near these four points of interest just look more balanced because they land one-third of the way into the frame. It gives your subject somewhere to live, and gives your eye something else to explore about the image. It's even true of vertical portraits, where the person's eyes are usually the main subjects of interest.

Make it odd

Painters, photographers, and graphic artists generally shoot for odd numbers in composition, not even ones. It provides tension and a sense of order at the same time. Shoot for geometric shapes when you can, as well as repeating patterns.

Watch your background and your foreground

Sometimes you pay so much attention to your subject that you forget about the background, with a disastrous or humorous outcome.

Remember that you want your photo to invite—or force—the viewer to your subject, and nothing distracts from a subject like an ugly or complicated background. Worse is when your background makes your subject look funny, like when you take a shot of someone with a cable going through their ears or a tree growing out of their head.

Also, if you're shooting wide enough to include their leg or base, give your subject someplace to stand. If it's a car, a person, or a toaster, pictures are more interesting when your subjects have a leg to stand on and something to support them.

Leading lines

Use lines to lead your subject into the scene. Starting in the lower-left corner is a popular method, as shown here with the footpath.

Frame your subjects

Use your subject's surroundings to frame him in the image. This gives him a sense of belonging to his surroundings, and tells more of a story.

Don't settle!

Shoot a lot. Not just a lot of subjects, but a lot of shots of the same subject. Try different exposures, try a wide-angle approach, and try to tighten it up a bit. Stand on a chair and shoot down. Lay on the ground and shoot up. Try it with the flash and without. Change the white balance. Shoot black and white. Hopefully you learned this in my earlier exercise, but it bears repeating: digital gives you versatility that you've never had before. Use it!

NOMENCLATURE: Front

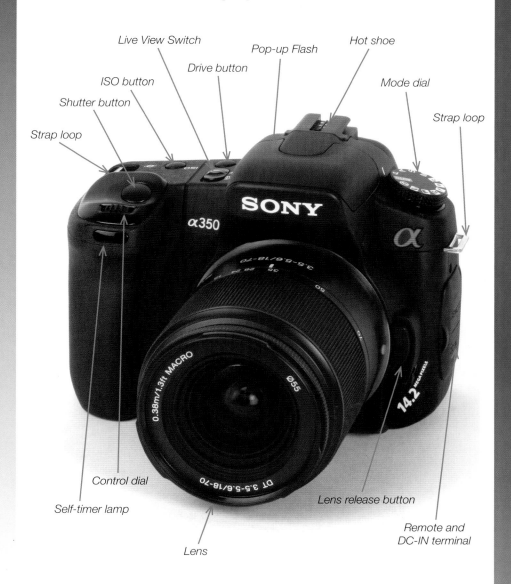

Live View Switch

Pop-up Flash

Hot shoe

Drive button

ISO button

Mode dial

Shutter button

Strap loop

Strap loop

Control dial

Lens release button

Self-timer lamp

Remote and
DC-IN terminal

Lens

NOMENCLATURE: Back

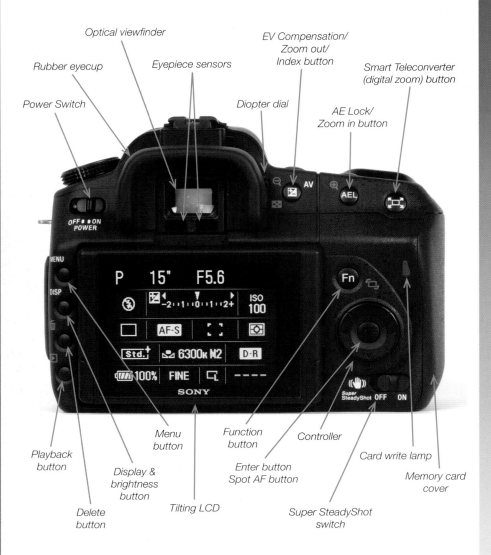

Optical viewfinder

Rubber eyecup

Eyepiece sensors

EV Compensation/
Zoom out/
Index button

Smart Teleconverter
(digital zoom) button

Power Switch

Diopter dial

AE Lock/
Zoom in button

Playback
button

Delete
button

Display &
brightness
button

Menu
button

Tilting LCD

Function
button

Enter button
Spot AF button

Controller

Super SteadyShot
switch

Card write lamp

Memory card
cover

The Camera

Section A: Record Modes
Section B: Viewing the Images
Section C: Menus
Section D: Memory Cards,
Batteries, and Maintenance

Section A: Record Modes

Before you start making great photographs, you have to become familiar with the tools at your disposal. Although the Sony A300/A350 is a well-designed camera that is easy to use, it has many modes and features that you should know about and learn to use so that you can select the right mode for the photo you want to make. We'll go over them briefly to give you a good idea of what your Sony Alpha SLR can do.

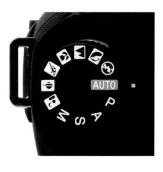

VIEWFINDER MODES

The Sony A300 and A350 have two distinct viewfinder modes: One is the normal mode of the single-lens-reflex camera, using the optical viewfinder; the other is a hybrid system that uses a second sensor inside the optical viewfinder area to capture a live viewfinder image and convey it to the tilting 2.7-inch LCD.

OPTICAL MODE

This first mode needs little explanation, except that in most digital SLR cameras, looking through the optical viewfinder is the preferred method for framing your images. Autofocus is generally

faster than most Live View methods, you don't have to struggle to see in bright daylight, and you're getting a truly live view of your scene at the speed of light. Both the Sony A350 and A300 have overcome that first limitation, because they use the same autofocus sensors in Optical mode as they'd in Live View mode. It's still a little more comfortable to compose your images via the optical viewfinder in bright daylight, though, and there is still some electronic delay when using the Live View mode when compared to the Optical mode. So when speed is important, stick with the optical viewfinder.

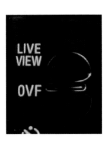

LIVE VIEW MODE

Live View mode still offers the advantage of framing your images from odd angles, including overhead. The Sony A300 and A350 have the further advantage of a tilting LCD screen that allows shooting from overhead or down low quite a bit more easily.

You can activate Live View mode by finding the Live View/OVF switch on the camera's top deck and sliding it forward. This moves a mirror inside the viewfinder that redirects the light to a small mirror, lens, and sensor inside the viewfinder that captures your Live View image. This switch also closes a shutter over the optical viewfinder to keep out stray light, making Live View mode a great way to shoot on a tripod, as it prevents light entering through the optical viewfinder from disturbing your camera's meter.

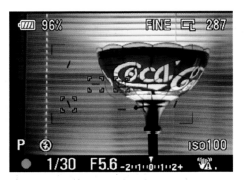

Display screens

Live View mode has a few display screens you can choose from. The first is the default screen, which includes battery life, resolution settings, number of images remaining, capture mode, flash status, ISO settings, and a duplication of the status bar you see in the Optical viewfinder. This bar includes focus status, shutter speed, aperture, an exposure scale, and an anti-shake warning and the Super SteadyShot status, plus a few more depending on what's active on your camera.

Pressing the display button while in Live View mode removes all but the status bar, but adds a very helpful Histogram display, to ensure your exposure settings look right *before* you press the shutter button (see section on the Histogram on page 57).

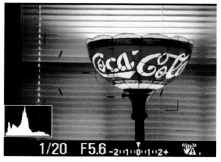

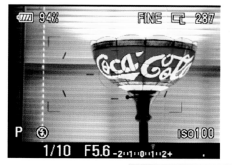

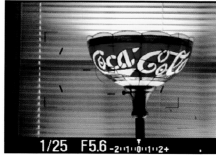

A third press on the Display button clears the screen of all but the bottom status bar, allowing for easy composition without distracting overlays.

Changes you make to the exposure in Live View are reflected on the LCD screen. Note the orange EV adjustment indicator that appears on the exposure scale in the Status display in the first image in the series.

Zoom mode

Live View mode also has a digital zoom function, which effectively crops the image to the size you see onscreen. Just press the Zoom button to the right of the AEL button on the back panel and the camera will zoom the view, first to 1.4x, then to 2x. Note that the AF area is automatically set to the center AF point, and the metering mode is set to Multi-segment.

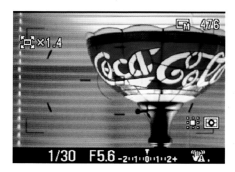

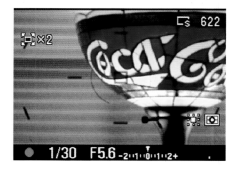

For the A300, the image is cropped to a 2,768 × 1,840-pixel or 2,032 × 1,360-pixel image at 1.4x and 2.0x respectively.

For the A350, the image is cropped to a 3,264 × 2,176-pixel or 2,416 × 1,600-pixel image at 1.4x and 2.0x respectively.

Also note that you can't use the Live View zoom mode when your capture resolution is set to RAW.

Tilting the LCD

Taking advantage of the A300 and A350's tilting LCD is quite simple: Just place two fingers under the LCD's Sony logo and lift gently. From there you can pull the LCD's hinge out and tilt it up well over 90 degrees, or down 45 degrees for easy overhead shooting. If you're only going to shoot with the camera overhead, it's almost as easy to place a finger on top of the LCD and tilt downward in one motion.

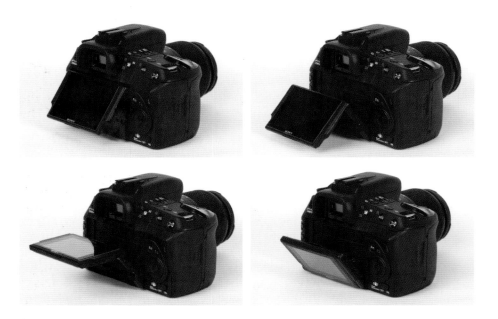

FULL AUTO MODES

The first mode is called Auto, but all of these Full Auto modes put the camera in full control of exposure. The Scene modes following Auto mode simply bias a few of the settings in one direction or another to suit a particular photographic purpose. Dynamic Range Optimization is turned on in these modes, and color, contrast, and sharpening are adjusted to suit the subject.

AUTO

Also known as Full Auto mode and Green mode, Auto mode puts the Sony A300/A350 in complete control of the exposure and focus decisions.

It's important to know that you can still adjust the EV or Exposure Compensation setting to modify what the camera is doing, either under- or overexposing your image by up to two stops. I encourage you to explore this capability at first in your shooting. Because the flash on the A300/A350 is manual, you'll need to pop up the flash if you think it's necessary.

FLASH OFF

Because the Sony A300/A350's pop-up flash deploys automatically in Full Auto modes, Sony included a mode that keeps the flash from firing. As such, there's no difference between Flash Off and Auto mode, except that it cannot deploy its flash in Flash Off mode. Use this mode in places where flash is either undesirable or prohibited, like museums and theaters.

PORTRAIT

Portrait mode biases the exposure toward wider apertures that will blur the background so that your subjects stand out in the image. Skin tones are also adjusted, for more flattering portraits. Again, you'll need to pop up the flash if you want a little fill with shadows in direct sunlight.

LANDSCAPE

Landscape mode—essentially the opposite of Portrait mode—biases the camera's settings toward smaller apertures to ensure that more of the image is in focus. Colors are also made more vibrant.

MACRO

Use Macro mode for extreme close-up shots. This mode sets apertures to the middle range to help optimize macro images. Be sure not to use the flash while shooting close-ups, and Super SteadyShot may cause blurring of images at close distances, because it was not designed for use in Macro mode.

SPORTS

Sports mode biases exposures toward faster shutter speeds to stop action. Autofocus is switched to continuous mode, so that it can track subjects moving toward or away from the camera, and drive mode is also set to continuous, so that you can capture multiple shots of the action just by holding down the shutter release button.

SUNSET

Unique to Sony digital SLRs (single-lens reflex cameras), the Sunset mode sets the camera's aperture to smaller settings, like in Landscape mode, but optimizes color settings for warmer colors. Normally, the camera would set the white balance to make the sunset appear white.

NIGHT VIEW/NIGHT PORTRAIT

Probably the most valuable of Scene modes, Night View/Night Portrait mode makes the camera ready for night shots. Getting good shots at night

is really difficult, but setting the camera to this mode makes it easy. With the flash down, you're in Night View mode, and the camera will keep the dark areas dark and expose for the highlights. Pop up the flash, and you're in Night Portrait mode. The camera will expose for both a person or object in the foreground, and leave the shutter open to capture the lights in the background. You and your subjects will have to hold very still in this mode to prevent ghost images, but it's easy to master with a little practice. I also recommend using this mode for more natural indoor portraits when using the flash.

ADVANCED MODES
PROGRAM

Program mode is a lot like Auto mode, but it allows you to change the combination of shutter speed and aperture that you use by spinning the Control dial left or right. The status display will change from P to Ps, to indicate that you've dialed in a Program Shift. In Program Shift, the exposure stays the same, but it can go from 1/100 second at f/11 to 1/60 at f/13 if you want to blur motion while panning, or to 1/125 at f/9 to reduce motion blur in low light, for example. This is another automatic mode that allows you to be creative while the camera still sets a proper exposure. Once you get used to how well your camera's meter works, you might feel quite at ease in this mode, using Program Shift and EV adjustment to make the modifications for you. Program mode is especially useful when you want to take some simple shots of family and friends without a lot of thinking involved.

APERTURE PRIORITY

When you really care what aperture is set—say, when shooting portraits, or when using a lens that produces soft images wide open—you want to shoot in Aperture Priority mode. You set the aperture you want, and the camera sets the proper shutter speed for the best exposure.

SHUTTER PRIORITY

When you want to capture action with either a fast or slow shutter speed, you want to be in Shutter Priority mode. You can set a slow speed to show blur as you pan to follow a subject, or set a faster shutter speed to freeze action. Either way, you set the shutter speed, and the camera does its best to set the proper aperture.

MANUAL

Manual exposure mode gives you complete control over both aperture and shutter speed. Turning the Control dial sets the shutter speed, and you must press and hold the AV button on the back of the A300/A350 to set the aperture. Use the scale on the rear Status display or in the viewfinder to check exposure. As you adjust either aperture or shutter speed, the virtual needle on the scale will move left or right to indicate the current

exposure value. The apertures you can choose vary by the apertures that are available on the lens that you have mounted. The longest shutter speed you can set manually is 30 seconds, but you can also choose a Bulb setting, which keeps the shutter open as long as you hold the shutter release button down. This can be useful for very long exposures at night, where you mount the camera on a tripod and set the aperture to f/16 so that you can leave the shutter open for many minutes at a time.

CHANGING THE ISO SENSITIVITY

Back in the film days, once you loaded a roll of film, you were stuck with it and its ISO setting until you shot the whole thing. If you'd loaded Kodachrome 25, a very slow, fine slide film that performed beautifully on sunny days, you were out of luck if your subject moved indoors or after sunset—at least until you finished that roll. Conversely, if you loaded fast films with ISO 400 or 800 sensitivities, your outdoor shots would require a high shutter speed and small aperture, limiting your artistic possibilities. Those of us who used manual cameras a lot learned how to change film mid-roll and leave the leader out so we could reload the canister to resume shooting. Many APS cameras also had a special mode that allowed you to remove film before it was finished and reload it later.

With digital, however, you can jump across the entire ISO range, from 100 to 3,200, by pressing a few buttons. Just press the ISO button on the top deck and use the Controller disk to navigate to your desired ISO setting. In full Auto mode, the Sony Alpha will set the ISO automatically, but as you learn more, you'll want to maintain more control over the ISO.

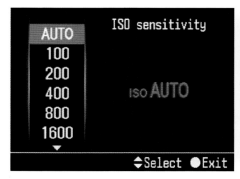 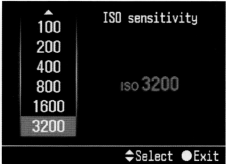

ISO ranges from 100 to 3200.

Generally, when shooting static subjects outdoors, ISO 100 is ideal. The sensor offers its best exposure accuracy and detail at that setting; higher ISO settings are asking the processor to make more and more guesses about what the sensor is seeing at each pixel. When you raise the ISO from 100 to 200, you're telling the camera that you're going to give it half

as much light as you did at the lower setting, also known as "one full stop" less light than you give it at ISO 100. So the camera has to build the image with less light, and that creates the possibility of errors. These errors appear as what we call "noise," making a grainy texture in the final image; and true to the character of noise, its "graininess" starts to appear in the shadows, where there is even less light available to make an accurate decision.

The good news is that technology has improved, and sensors can handle higher ISOs than they used to, so you can feel comfortable cranking the ISO of your Sony A300/A350 up three or four stops to ISO 400 or 800 with little worry about how your image will turn out. You should still be able to print at least up to 8 × 10-inch images, even at these high settings, with little or no visible noise. If you don't think you'll be printing larger than 4 × 6-inch prints, you can also usually venture into ISO 1600 and 3200 and still get a very appealing shot—something you'd struggle to do with film.

However, with a little freedom comes great responsibility, and with this new ability to change the ISO on the fly comes a caution: you must remember to reset your ISO to the lowest setting after you're done shooting in low light. As a habit, before switching a camera off, I reset its ISO to 100 so that next time, I'm ready to shoot at the highest quality my camera can produce.

TIP

Preflight checklist

When I first started shooting with a digital SLR, I found myself overwhelmed by the huge number of variables that I could easily overlook while shooting. After I mindlessly shot several important client portraits at ISO 1600, when ISO 100 would have been better, I printed up a sheet with a few "preflight" items that I always want to check before shooting, and I taped it to the back of the camera. Although it's not glamorous, it has saved me a lot of reshoots and lost moments. That list includes:

ISO

WB

EV/Flash EV

Size

AF

SSS (for Super SteadyShot)

Drive

EXPOSURE COMPENSATION

Exposure compensation is as simple as it sounds: the meter has decided on a given exposure that may not be correct, so you can compensate for it by adjusting the EV (exposure value) setting. All it takes is a light or dark shirt at the center of the image to throw an exposure system off; or worse, a black tuxedo and a white dress, a common combination at weddings. Thanks to exposure compensation, indicated on the Sony A300/A350 by a +/− button to the right of the optical viewfinder, you can leave the camera in any of the auto or semi-auto exposure modes and tell the camera to over- or underexpose your images as you shoot.

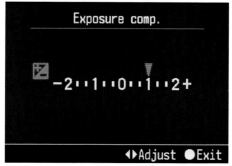

Press the EV/AV button and use the Controller or Control dial to adjust the exposure.

BRACKETING

If in doubt about what exposure to choose, you can also "bracket" your exposures. Bracketing is a common technique used by pros—even in the days of film, as it's most often during the special moments, like sunsets, that there's no time to spare. The camera takes one shot at what it has decided is the proper exposure, then it brackets that with another exposure that is slightly underexposed, and one that is slightly overexposed, thus increasing your odds of capturing a well-exposed image.

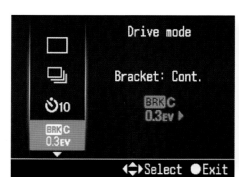

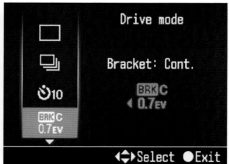

Use the right and left arrows to choose between the two modes. Select 0.3EV for a minor change between shots, and 0.7EV for a more significant change.

These three shots differ by 0.7EV. Note the extreme differences between them. I'm guessing that this is why Sony didn't go all the way to 1.0EV, as such a broad range is seldom helpful.

| P | 1/60 | F9 |
| | | |

Note the three arrows over the EV scale. In Single Bracketing mode, the arrows disappear after each value is captured.

You access Bracketing mode on the A300/A350 by pressing the Drive button on the top deck and using the Controller's up and down arrows to move to the two available bracketing modes. By default, both are set to the 0.3 EV range, but if you press the right arrow on the Controller, it changes to a 0.7 EV range. If you select 0.3 EV, the camera will vary the exposure by one-third of a stop. If you choose 0.7 EV, the camera will vary the exposure by two-thirds of a stop.

You can choose from Continuous and Single exposure modes. In Continuous mode, just hold down the shutter and the Sony A300/A350 will fire off three shots in a row. If you stop at two shots, and release the shutter, the sequence will start over the next time you press the shutter. Likewise, if you take just one shot, it will always be the exposure that the camera prefers, or 0.0 EV. This is the mode I use when shooting handheld, resulting in fewer mistakes. However, if you want to shoot in single shot mode, you have to release the shutter with each shot. The Status display on the back first shows three arrows over the selected EV settings, and deletes

one with each image captured, to show which EV settings have yet to be captured. This is better for tripod work at night, because you can reduce camera vibration by taking one shot at a time.

The other bracketing option available is in the Menu, under Bracket Order. The default setting is to shoot the first shot at the camera's preferred exposure, then the negative EV shot, and then the positive EV shot. The second option is to capture the negative EV shot, then the proper exposure, then the positive shot. Either way is fine. I normally prefer the latter mode, but with the Sony A300/A350, I can set the former mode and shoot in Continuous mode and shoot one shot if I don't want to bracket for that image, or just keep going for the full three shots if I do want to bracket—handy!

Drive mode button

DRIVE MODES

Access the different drive modes by pressing the Drive button on the top deck of the Sony A300/A350. It is to the left of the ISO button.

SINGLE-SHOT ADVANCE

Single-shot takes one shot with each press of the shutter button. To take a follow-up shot, you have to release the shutter button at least halfway and press it again. If you release it only halfway, the A300/A350 does not refocus, but fires again; this is good for quick follow-up shots, because there's no time wasted reacquiring focus.

CONTINUOUS ADVANCE

Setting the camera to Continuous drive mode allows you to capture up to three frames per second, depending on the shutter speed. Just hold down the shutter release button as you track your subject. The number of shots remaining in the image buffer will count down as the buffer fills.

If you are tracking a subject with Continuous mode, be sure to set the autofocus mode to AF-C (Continuous autofocus) or AF-A (Automatic autofocus), so that the camera knows to refocus before every shot. Otherwise, in AF-S mode (Single-shot autofocus), the camera's focus is set on the first shot only. If the subject moves, it will likely move out of focus, but AF-S mode does not compensate.

SELF-TIMER

The Sony Alpha's Self-Timer can be set to fire after ten seconds or after two seconds. Press the Drive mode button, navigate to the Self-Timer icon, and press the left and right arrows on the Controller to change from ten to two seconds. Ten seconds is a good setting for when you want to get into a picture, and two seconds is more often used for tripod work, when you want the camera to stop any residual motion you may have caused before it actually takes the picture.

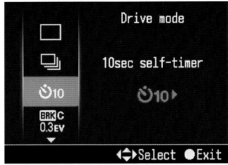 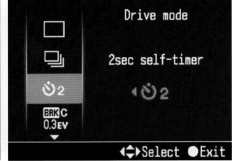

Switch between 10 and 2 seconds with the right and left arrows.

TIP

Cover the viewfinder

SLRs are usually used with the viewfinder up against your eye, but when shooting multiple self-timer shots on a tripod, we often don't look through the viewfinder for every shot. It's a good idea to cover that viewfinder when you're using an autoexposure mode, because stray light can enter from the viewfinder and change the meter's reading dramatically. The A300/A350 comes with a viewfinder cover that you can mount on the camera strap so that it's ready for just such an occasion.

BRACKET: CONTINUOUS

As explained in Exposure Compensation, the Continuous Bracketing mode takes three shots at different EVs when you hold down the button, and stops after three. If you take only one or two shots, the sequence resets when you let go of the shutter button. You can set the Sony A300/A350 to take the first shot at zero compensation, then the negative value, then the positive value; or you can set it to take negative, zero, and positive. Select Continuous Bracketing mode by pressing the Drive button and using the left and right Controller buttons. You can choose either 0.3 EV or 0.7 EV by pressing the left and right arrows on the controller when selecting the mode. The most useful bracketing mode is to set the order to 0, −, + and to Bracket Continuous. You can then shoot just one shot if you don't want to bracket, or hold it down for all three shots if you want to be sure of your exposure.

BRACKET: SINGLE

Single Bracketing mode is probably better for tripod shooting, when you know you're going to want to take all three exposures. The Sony A300/A350 shows you by elimination which shots have been fired, and which remain. Three arrows appear over the three settings, and go away after each shot. The arrows then reset after each sequence of three is complete. It's important to remember to turn this bracketing mode off after you're done, or two-thirds of your images will be under- or overexposed.

BRACKET: WHITE BALANCE

Even at the HiWB bracketing setting, the difference is subtle, transitioning from neutral, to colder, to warmer.

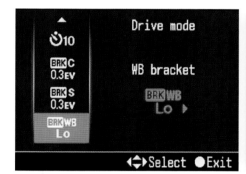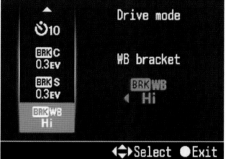

Choose WB bracket Lo and Hi by pressing the right or left arrows on the Controller.

White Balance Bracketing mode is a good idea if you're having trouble getting Auto White Balance to deliver consistent results in a given situation. Press the Drive button and select the final icon. It will be labeled either LoWB or HiWB. This bracketing mode is a little different from the previous two in that it takes only one shot, but saves three separate images, each with a different white balance setting. The first is the default, the second is colder, and the third is slightly warmer. LoWB's effect is more subtle, and HiWB's effect more dramatic.

EXPOSURE AND METERING
AVAILABLE METERING MODES

The Sony A300/A350 has three metering modes. It's good to know which one is right for your shooting situation. For basic snapshots, Multi-segment mode measures a broad area across the frame and makes an intelligent decision about what it sees. Usually this mode is fine, but you'll want to

know when to use the other two modes. Just press the Fn button on the camera's back to bring up the Function menu, and use the Controller to navigate to Light Metering mode. The following choices are available.

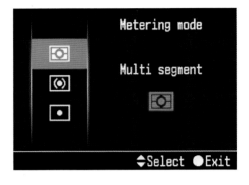

Multi-segment

Using 40 honeycomb-shaped sensor areas, the Sony A300/A350 evaluates the scene to search for problems such as backlighting. This is commonly encountered when shooting a subject against a bright background, like a sunset or a window. It should also compensate for bright or dark clothing. It's a great all-around snapshot mode, saving many a shot from common problems. But it doesn't solve all problems, and because you can check your exposure on the LCD, you can switch to one of the other metering methods if you want greater accuracy.

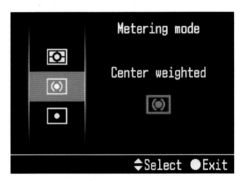

Center-weighted

Center-weighted is the old-standard metering mode, once the default on early film SLRs. This mode concentrates its reading on the center of the frame, but includes most of the rest of the frame as well. As there's no intelligence to look at the scene like in Multi-segment mode, this mode is easily fooled, especially if you're shooting with your subject off-center or backlit. When using Center-weighted metering, you'll have to employ your own intelligence to set the EV compensation based on your own evaluation of the scene's light and dark areas.

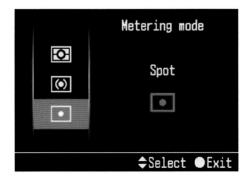

Spot

Spot metering is the first alternate mode you want to turn to if Multi-segment mode isn't getting the job done. The meter's sensitivity is confined to the circle in the center of the viewfinder. Spot metering mode allows you to quickly meter off a neutral subject in the scene, or your subject's face, to ensure that you're getting the proper exposure.

This mode can really help you set up for shooting in a difficult situation, such as a beach scene, a bride in her white dress, or even a dark room lit by a single light source. You can also take multiple spot-metered readings and manually average them to make sure that you have detail in all areas.

When shooting in one of the auto or semi-auto modes with Spot metering mode active, meter off your chosen area, press the AEL button (which stands for Auto Exposure Lock), and then recompose your image. In Manual exposure mode, you just set your exposure, compose, and press the shutter button.

Spot mode is another mode that you want to disable when you're done with it, as it can cause a lot of problems with general snapshooting if you forget that you're in this mode.

AE LOCK

Sometimes it's desirable to set the exposure before you compose the image, especially in Center-weighted and Spot modes. It's the best way to make a silhouetted image, for example: pointing your camera at the sky, pressing the AEL button, and recomposing the subject that you want in silhouette. You could just half-press the shutter while doing this, but the shutter button also sets focus, and most often you want exposure from one area and focus in another. Just press and hold the AEL button to set, then recompose and shoot.

If you keep the AEL button held down after exposure, you can continue shooting at the same setting. Once the button is released, the lock is removed.

You can do a few tricks here as well. If you flip up the flash, you can use the AEL button to hold a slow exposure and still fire the flash, getting the foreground properly exposed, while the background is allowed to burn in. You have to be in one of the following modes to do this: Auto, Program, or Aperture Priority. It's roughly equivalent to switching the A300/A350

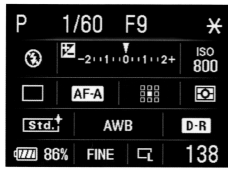

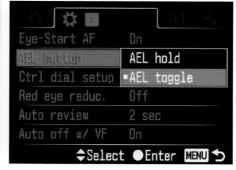

When you press the AEL button, an asterisk appears in the upper-right corner of the LCD Status display to indicate lock.

Select AE toggle to lock exposure for a range of shots.

into Night Portrait mode. You and your subject will have to hold still, or you can use a tripod to hold the camera still.

But it gets better. In Custom Menu 1, you can change the AEL button from its default AE hold function to an AE toggle function. This means that you must press the AEL button only once to lock exposure—no matter how many shots you take. To remove AE Lock, just press the AEL button again.

The next two options are even more useful. Because you usually want to focus your exposure setting on a very small area when performing AE lock, you'd do better to switch to Spot metering mode when performing an autoexposure lock. Well, there are two more options in Custom Menu 1 pull-down, and they automatically activate AE Lock in Spot metering mode, regardless of what exposure mode you're in. You get Spot AE Hold and Spot AE Toggle modes. Spot AE Hold is my preferred setting, as it offers instant access to Spot metering mode and holds onto the result for me; and then I can return to Multi-segment metering for simpler subjects.

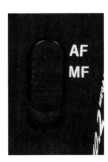

AUTOFOCUS

Focus method is selected by sliding the switch on the lower left side of the Sony Alpha's body, on the lens housing. Slide the switch up for AF (autofocus), and down for MF (manual focus).

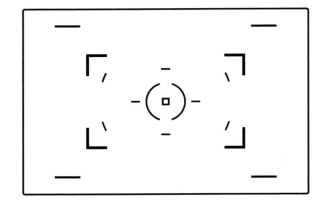

With a multiple-angle nine-point phase-detect AF system, the Sony A300/A350 has much of the frame's center covered by autofocus points. The center AF point is cross-type, making it sensitive to more subjects, and the eight outside sensors are oriented as indicated in the viewfinder. The slight tilt to the outside four AF points offers more versatility with horizontal and vertical lines that may occur in these areas.

You have control over three AF areas and four AF modes, or you can turn off autofocus with the Focus mode switch on the left of the lens housing and use the manual focus ring on the lens body.

The Sony Alpha also features Eye-start AF, which uses two sensors below the optical viewfinder to detect when your eye approaches the viewfinder, and starts the auto-focusing process before you've even settled in.

The Sony A300/A350 tells you when the lens is in focus, which AF points were chosen, and also when the lens is not in focus, via several methods—all located in the optical viewfinder. First, the chosen AF points flash red briefly to indicate which AF points are reporting sharp focus. In the viewfinder's status display, a green dot glows solid when AF is achieved, and flashes when it cannot be achieved. When moving subjects are being tracked, a green dot with two pair of brackets appears and glows solid. If the subject cannot be locked, the green dot in the middle does not appear, but the brackets do. If focus is not achieved, the shutter cannot be tripped.

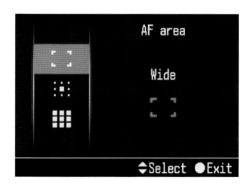

AUTOFOCUS AREAS
Wide AF area

In Wide AF area, the camera looks at the scene and selects which of the nine areas that it has determined should be in focus. The camera generally chooses the closest object in the scene. Once one of the points is selected, it flashes red briefly and the camera beeps. If you don't agree with the camera, you can press and hold the AF button in the center of the Controller to force the camera to find focus at the center AF point.

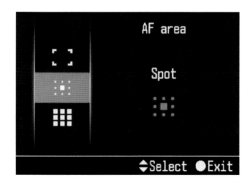

Spot AF area

In Spot AF area, the center AF point is used. Because this is the most accurate AF point, it's not a bad idea to stick to this AF point when focus is critical.

Local AF area

Local area selection allows you to choose from among the nine AF points. If you're locked down on a tripod, for example, it might not

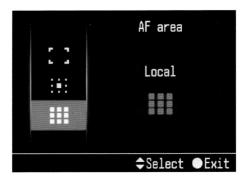

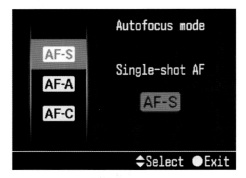

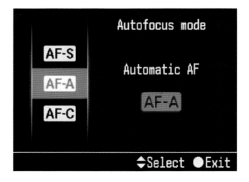

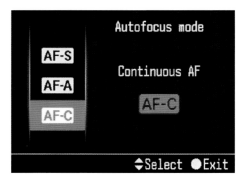

be desirable to recompose after every shot, so you can put your most interesting subject under one of the AF points and keep focusing right where you want to. Use the Controller on the back of the camera to select any of the eight outer points directly, as it's an eight-way controller disk. Pressing the center AF button returns to the center AF point.

AUTOFOCUS MODES
Single-shot AF (AF-S)

AF-S mode is pretty self-explanatory: focus is set just once, and if you don't like the selected AF point, or if your subject moves, you have to release the shutter and half-press again for a new focus point. This mode is best for subjects that won't be moving, and it is the mode to use if you want focus confirmation before you press the shutter.

Automatic AF (AF-A)

AF-A mode is a mixture of Single-shot and Continuous. The camera looks at the subject and determines whether it's stationary or moving. If stationary, the camera locks focus and sounds a confirmation beep. If the subject is moving, the A300/A350 switches to Continuous AF mode and begins to track the subject.

Continuous AF (AF-C)

AF-C mode tracks a moving subject, attempting to keep it in focus. It also predicts where the subject will be when the shutter is finally open and the exposure is made, adjusting the lens accordingly. No confirmation beep will sound, but the tracking AF point lights up.

DIRECT MANUAL FOCUS

Direct Manual Focus, selected by sliding the AF switch to the left of the camera on the lens housing in a downward direction, allows the user to set focus by turning the focus ring on the lens body. With the kit lens, the focus ring is the knurled ring at the front of the lens body. "MF" will appear on the A300/A350's Status display.

When in autofocus modes, you can adjust the focus ring after AF is achieved, but you have to repeat this procedure with each frame captured, as the camera refocuses after each shot. Certain Alpha-mount lenses allow manual focus, thanks to their built-in manual focus lock buttons.

SUPER STEADYSHOT

Whenever possible, you should work to hold the camera as steady as you can. For times when you can't hold it as steady as you need to, Sony has included Super SteadyShot technology. A high-speed processor inside the Sony A300/A350 reads the input from very sensitive electronic gyroscopes to detect camera motion, and actually moves the imaging sensor inside the camera body to compensate. Common sources of motion are breathing, hand tremors, and heartbeat, but the most common and most damaging movement is when photographers press the shutter button.

USING SUPER STEADYSHOT

You'll know that you need Super SteadyShot when you look through the viewfinder and see a flashing hand icon. Putting Super SteadyShot to work is really as easy as flipping the switch on the back of the camera. But to use it to its fullest, there is one thing you need to know. Although some image stabilization systems actually stabilize the image in the viewfinder, most sensor-shift systems can't. Instead, Sony employs a five-bar graph to tell you just how much compensation it's doing at any given moment. Five bars means that it's doing a lot of compensation, and the odds are that it won't be able to compensate for the increased motion when you press the shutter.

This is an opportunity to see just how well you can stabilize the camera yourself, because as you hold the camera more steadily, you'll be able to watch the bars decrease. When it gets down to two or three bars, slowly squeeze the shutter button.

With only a little practice, Super SteadyShot will allow you to take pictures in situations you couldn't before, including indoor shots without flash.

If the hand is flashing in the viewfinder, you need to pay close attention to the five bars just to the right. Wait until the count goes from four or five to one, two, or three and slowly squeeze off your shot.

COLOR AND WHITE BALANCE

If you're new to digital photography, you may not know anything about white balance or color space.

Most of us accustomed to using daylight-balanced negative film just took pictures in whatever kind of light we wanted and the pictures came out all right. In general, unless you shot slide film, the advanced film processor labs in most stores could easily correct for discoloration due to different light sources. As for color space, that was just what the film could capture; most folks have never even heard of color space.

But now that color and white balance have gone digital, there are a few more choices you can make. You can either rely on your A300/A350's Auto White Balance (AWB) to figure out the best setting, or set it yourself as the light changes. The good news about white balance is that you can check the results on the LCD screen and make adjustments if necessary.

The Sony A300/A350 does a pretty good job in AWB mode, but occasionally it'll need to be set manually for the particular type of available light to get closer to the right colors. It always helps to have something white in the scene for the camera to work with.

Because cameras see a little differently from us, you'll find that your A300/A350 will sometimes make a scene look whiter than you see it. Tungsten light is usually very yellow, but the camera will try to make it appear white. Candlelight is yellow, too, but if the camera makes that white, it looks unnatural. Sunsets, too, will sometimes turn white when you really want them to appear orange or yellow. That's why the Sony Alpha has a Sunset Scene mode.

SETTING WHITE BALANCE

You can set white balance on the Sony A300/A350 in any mode and the camera will make the adjustment. You can even adjust white balance in Full Auto mode, which seems odd.

Just press the Function button, move the highlight to the White Balance selection, and press the center of the Controller (marked AF) to bring up the White Balance menu. Use the up and down arrows on the Controller to select the mode you want to use.

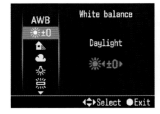 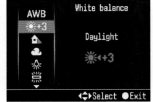 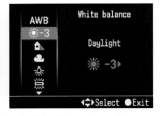

Adjustments to the default preset white balance settings are easy, but they stay adjusted until you change them back.

You can also fine-tune every mode except AWB to various degrees to better match the particular lighting. Just highlight the mode that you want to adjust and press the left and right arrows, which makes the default setting either colder (bluer) when moving toward the negative with the left arrow, or warmer (toward yellow and orange) with the positive values by pressing the right arrow key. If you do choose to make this adjustment, remember that the camera retains it until you change it back, so be careful. This can be desirable, of course, because you may find that for your needs, a +2 on the Tungsten setting gives you that warm glow you're looking for with Tungsten lighting, but without the haphazard variability you get in AWB mode.

Available modes

AWB Set the A300/A350 to Auto White Balance when you want the camera to make the white balance choice for you. If that's doesn't produce the desired effect, consider setting the camera to one of the other modes listed here.

Daylight Use Daylight mode when you're shooting in direct sunlight. You might want to adjust this setting somewhat depending on the season, or if you're just not quite getting the color you want. You can move it three steps negative to make it bluer or three steps positive to warm it up toward yellow and orange tones.

Shade For pictures of people on a sunny day, it's better to shoot in the shade, so it's important to know about this setting. Sometimes the camera's AWB setting sets it properly; but if it doesn't, you'll find that your images look cold and blue. Set it to Shade, however, and your images will warm up enough to look right.

Cloudy On overcast and cloudy days, switching to Cloudy warms your images back up, as it does with the Shade setting (just not as much). Shade can actually appear colder than on a cloudy day, because the blue light from the sky can make an image bluer; the Cloudy setting does slightly less warming for this reason.

Tungsten Tungsten lighting is what you get with the common everyday lightbulb, named for the filament in the bulb that glows when electrified. It gives off a pleasant warm glow that we're all familiar with, but most of us probably don't notice—until we take a picture and it looks too yellow. Most digital SLR cameras leave too much yellow in a Tungsten scene, and some digital cameras take too much yellow out. The Sony A300/A350 usually leaves a good amount of yellow in the scene—sometimes too much, which is when you should set your A300/A350 to Tungsten mode. It'll generally make white items white, but you can still make it a little warmer by pressing the right arrow. If you're not shooting RAW indoors, this is worth your attention. (White balance is not locked in for RAW images, which means you can assign your own white balance setting when you

view the image on the computer.) For more on RAW images, see the Quality section on Page 63.

Fluorescent Fluorescent has to be the toughest light source of all, especially now that there are so many types. The advent of compact fluorescent tubes tuned to emulate different color temperatures has made it a guessing game to figure out which one will work with your fluorescent setting. Thankfully, fine-tuning is easy with the Sony A300/A350, and you get an extra step in the warming direction to help compensate for very cold fluorescent light. Some bulbs might require you to switch modes entirely, especially as the technology improves. There are a few bulbs that emulate Tungsten and Daylight modes well enough that you'll want to switch to one of these two modes and fine-tune from there for proper color balance.

Flash Generally, your Sony A300/A350 selects the proper white balance when you're using your on-camera flash, but if you want to force it to balance the light for flash only, useful in darker situations or when other light sources are confusing the Auto White Balance system, this is the setting to pick. It's also good if you're using only external strobes: Sony strobes or professional strobes.

Color Temperature You can also set the color temperature in degrees Kelvin, a great option if you know the approximate temperature of your light source. You can measure it with a special light meter, or use the Custom setting in your Sony Alpha digital SLR to find out the exact temperature of your light source and dial that in (see the following "Custom" section for more on Custom mode). Just as with the adjustments in each previous mode, moving from 2500 K to 9900 K takes you from blue to red bias in color temperature.

Color Filter In the same dialog screen as Color Temperature is Color Filter mode, which provides a little more than blue and red color correction, completing the basic color balance equation. Press the left arrow to discover nine levels of Green filter correction, and move it right for nine levels of Magenta correction. When you experiment with the Custom mode, the final option in this section, you'll see that often that true white balance can be achieved only when you apply both Kelvin temperature adjustment and a Green or Magenta filter. Remember, it's a digital camera and experimentation will cost you nothing but a little electricity and some time—and the payoff will be substantial if you learn about color balance.

Custom You need a white or gray (color neutral) object to set a custom white balance. You can buy a white card from your local photography store, or get one online. You might also want to consider a WhiBal card, which is a special piece of plastic calibrated to give your meter just what it needs for better white balance (www.whibal.com). In a pinch, a piece of white printer paper will do.

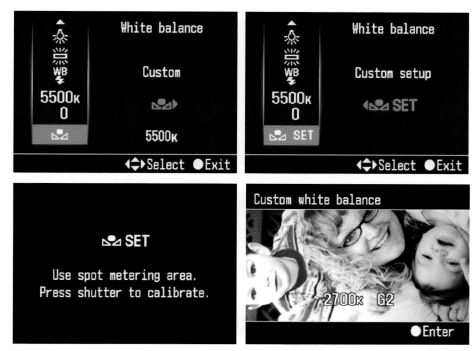

When you really need it right, set your own white balance.

To set a custom white balance, select Custom, then hit the right arrow, then press the center button. The camera's screen will go black, except for the words "SET Use spot metering area. Press shutter to calibrate." Look through the viewfinder and point the camera's center area at a white or color-neutral area and press the shutter button. The camera takes a photo to use as a reference, but does not save it. The selected temperature setting appears on the screen, including the selected Kelvin value and color filter applied. You must then press the center Controller button to lock in the color temperature.

Mix it up! Now that I've told you how to adjust your camera to capture images with the right white balance, I'm going to suggest that you break the rules. There's no reason to accept the perfect white balance in every scene, and it's the photos that look a little different that are really eye-catching.

SETTING COLOR SPACE

Color space is the amount of color that your camera can capture. There are two color spaces to choose from in the Sony A300/A350. The most commonly used color space in digital cameras is sRGB, so this is the default setting on the camera. But you can choose to use Adobe RGB instead. Why would you use one over another?

These shots were taken in afternoon daylight in spring, but some of these modes make the weather look quite a bit different. Remember that depending on the true light source, these different modes produce a different tint from what you see here. From left to right, White Balance settings are Auto, Daylight, Shade, Cloudy, Tungsten, Cool Fluorescent, and Flash.

First, you need to understand a little more about color space in general, because it doesn't just apply to how many colors your *camera* can capture. Monitors also have color spaces, and so do printers. In fact, sRGB was designed to define all the colors that an average computer monitor can display. Only very expensive monitors can display Adobe RGB natively, so here's where the bottleneck occurs. If you set your Sony A300/A350 to capture Adobe RGB, your monitor won't be able to display all the colors. Your printer will be able to print all the colors, but you won't be able to see or properly modify the colors on your computer before printing, so you'll have quite a dilemma. Adobe RGB is better, because it gives you more colors, more closely approximating the human eye's abilities, but your monitor can't display those colors.

So which should you choose? If you're not prepared to get into color management just yet, you're better off sticking to sRGB. You won't have as many surprises and you'll never know the difference. If you've learned to handle your camera with some skill and want greater control over your pictures, you might want to investigate how to set up a color workflow that includes your camera, your computer, and your printer.

DYNAMIC RANGE OPTIMIZER

Sony's Dynamic Range Optimizer (DRO) modifies the highlights and dark portions of an image to improve detail in both areas. Digital cameras are a lot more like slide film than the more popular negative film of days gone by. Negative film was able to retain a great deal of detail in highlights and shadows, and film processors at your local drugstore could get a good image from an improperly exposed image by pressing a few buttons. Slide film, or positive film, on the other hand, can lose all detail, especially in highlight areas, and no amount of processing will bring it back. If a bright or dark part of your image is over- or underexposed, the camera records no detail in that area: it's just all white or black. Because images are saved with red, green, and blue areas, you can also have one color "blow out," which very often happens with red. (When a color "blows out," or "clips," it has no detail—just color.)

DRO takes a look at each file before saving it as a JPEG image, and modifies the "tone curve" to retain more detail in those areas, preventing most, if not all, parts of the image from "blowing out" or "plugging." (When shadows go irretrievably black, we say they are "plugged.")

The Sony A300/A350 has three settings for DRO. The first is Off, which you can select if you don't want the camera messing with your JPEG images. The second is Standard DRO, which attempts to perform this curve adjustment across the entire image. This mode works pretty well in most cases, keeping most of the data in an image from blowing out or plugging. The third mode, Advanced DRO (DRO+), is a little more sophisticated, performing its work differently across the image. It analyzes light

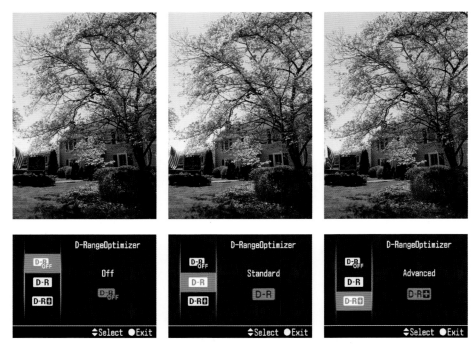

The difference is subtle here, but you should see a difference in the tree trunk, the highlights on the flowers, the blue sign, and in the bushes.

and dark portions of a captured image individually and applies its correction where needed, and it works harder to maintain highlight detail.

Beware that Advanced DRO can reduce the total number of images you can capture in a single burst, so be selective in its use. I suggest using Standard DRO when shooting action or children, and confining your use of Advanced DRO to tricky lighting situations where time is not important, like when taking pictures in a church or a darkened room where getting everything right is crucial. Advanced DRO does have a tendency to reduce image contrast, however, so I recommend using it sparingly.

Because DRO also works only on JPEG images, a good insurance policy for important images is to shoot RAW as well, just in case DRO's modifications aren't what you had in mind. You can always apply DRO after capture in the Sony Image Data Converter.

CREATIVE STYLES

The Sony A300/A350 includes Creative Styles to make it easier to pick a group of settings that are particularly useful for specific types of photography. Each is just a set of adjustments for contrast, saturation, and sharpness that are ideal for certain subject types, but that also include the

ability to increase or reduce any of these three settings by up to six steps. All of the following modes use sRGB mode (except for the Adobe RGB mode).

To select these modes, go to the Record menu and select Creative Style. Then use the up and down arrows to select the mode of your choice. To change the contrast, saturation, and sharpness of a particular style, highlight it and then press the right arrow. Use the right and left arrows to select from the three options and then use the up and down arrows to change the values. Once you've made your changes, press the left arrow again, and press the OK button to select the option.

STANDARD

Standard mode is the default setting. It renders most colors either accurately, or just a little brighter than normal, with elevated contrast and sharpness—image characteristics commonly preferred by consumers.

VIVID

Great for taking pictures of landscapes and foliage, Vivid mode pumps up color to produce bold, vibrant images. Both colorful scenes and particularly drab scenes could benefit from Vivid mode.

PORTRAIT

Tuned to create flattering skin tone and texture, Portrait mode reduces sharpness, contrast, and color to deemphasize blemishes in pictures of people, producing a soft, natural look.

LANDSCAPE

Much like Vivid mode, Landscape mode increases saturation, contrast, and sharpness to bring up detail and colors, because Landscapes are seldom as colorful as we think they are. Be especially careful about increasing saturation in Landscape or Vivid mode, as colors can "clip," losing all detail.

NIGHT VIEW

Contrary to how it sounds, Night View mode actually reduces contrast somewhat, to emulate what the human eye sees at night, leaving slightly more detail in subtle shades, rather than emphasizing the blackness of night.

SUNSET

Sunset mode emphasizes yellow and red tones, while increasing saturation and contrast, to make more beautiful sunrise and sunset colors.

There are occasions when using Black and White mode, or any of these other extreme color modes, that you'll later wish you had a color version of the photo to work with, so it's wise to turn on RAW+JPEG capture as a form of insurance. If you have the RAW file, which is a pure, uncompressed capture from the sensor, you can always make one or more versions of the photograph in multiple color spaces, or even multiple shades of black and white. See page 63 for more.

BLACK AND WHITE (B/W)

Black and White mode removes all color information, storing only neutral black and white tones.

ADOBE RGB

When you want to capture a fuller range of colors, shoot in Adobe RGB. You can capture a wider range of greens and reds. Though you won't be able to see these colors on your screen, you can output them to a printer for better landscape and foliage shots, and truer colors overall. It's better to invest in a color management solution, like a color calibration tool. The Spyder 3 from ColorVision is a good place to start.

FLASH

Though I generally caution against using flash constantly in your photographs, very often it's the only option to get a properly exposed shot. Deploying the Sony Alpha's flash is easy. If you're holding the camera properly and ready to shoot, your thumb should be well positioned to move up the left side of the camera's lens housing and press the button it finds there, just beneath the flash itself. To close the flash—a good idea when you're not using it, to avoid damage—press down on the flash until it locks back into place.

The Sony Alpha's pop-up flash serves well as a close-range fill flash.

The Sony A300/A350's flash pops up automatically if it's needed in the fully automatic modes, but you can't set the flash to pop up automatically

in the more creative modes, like Program, Shutter, Aperture, and Manual modes. Likewise, while you're in one of the Automatic modes, you can't force the flash to pop up; you have to wait until the camera decides that the flash is necessary, or you can manually set one of the other Flash modes, like Fill, SlowSync, and so on. When you do deploy it, however, the flash will fire every time. That's important to know if you need to use the flash for its autofocus-assist function.

FLASH METERING OPTIONS

The Alpha's built-in flash meters in two ways, which can be selected in Record Menu 1 under Flash Control. The default mode is ADI, which stands for Advanced Distance Integration. Using information from the lens, including focus, distance, and aperture settings, and also by firing a preflash, the camera determines the proper flash intensity. This distance information reduces the likelihood that a bright, reflective, or dark image will cause an exposure error. In Pre-flash TTL (through the lens) mode, the camera fires a preflash to determine the proper exposure. No other data is used, which can result in errors (depending on the subject).

FLASH EXPOSURE COMPENSATION

If you find that the camera is giving more or less light than you want on your subject, you can use Flash Exposure Compensation to reduce

TIP

You can use both Flash Compensation and Exposure Compensation together. Flash Compensation controls the flash intensity, and Exposure Compensation controls how long the shutter stays open or the aperture size, both of which affect the ambient light exposure. Reducing the fill flash exposure by selecting a negative Flash Compensation value can help blend the two light sources and make more natural-looking photographs. Both compensation values will appear on the Alpha's detailed status display.

or increase the exposure. Go to Record Menu 1 and scroll to the bottom item: Flash compensation. Unadjusted, the value to the right should read +/− 0.0. Press the OK button. You'll see a dialog box that looks similar to the exposure compensation scale. Use the left and right arrows to select the value you want (left for reducing the flash power, right for increasing it).

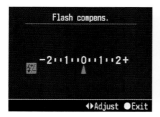
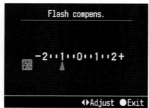
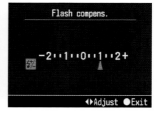

Flash Exposure compensation actually increases or decreases the output of the flash.

FLASH MODES

Flash modes are selected under the Function menu. Press the Fn button, then navigate to the Flash mode menu item. The following mode options are available.

Flash off

The flash will not fire at all when this option is selected. This flash mode is not available in Program, Shutter, Aperture, or Manual exposure modes (to prevent the flash from operating in these modes, keep the flash head down).

Auto

With this flash mode selected, the flash fires if the subject is too dark. It will also fire if light is streaming into the lens and a shadowed foreground object is detected to serve as fill flash. This option is also unavailable in Program, Shutter, Aperture, or Manual modes.

Fill-flash

Choose the Fill-flash flash mode to fill in harsh shadows encountered in direct sunlight. These harsh shadows are at their worst when the sun is high in the sky, making eye sockets dark and foreheads and cheeks shiny. Depending on the intensity of the shadows, you might want to adjust the Flash compensation to make the flash stronger or weaker as conditions dictate.

Slow sync

The Slow sync flash mode is desirable when you need a little help from the flash, but you want to maintain the ambient exposure. The shutter usually stays open a little longer after the flash fires to capture the color of the ambient light and background. This mode is also great in night scenes, when you want the background lighting to burn in a little bit so that your subject isn't surrounded by blackness.

Rear sync

Similar to Slow sync, the flash mode Rear sync is usually used in slow exposures of moving vehicles, so that the light trails behind the car rather than in front. The shutter opens to make the ambient exposure, then fires the flash right before the shutter closes. Thus the light trails are recorded first, then the flash of the moving vehicle.

Wireless

The Sony A300/A350 can wirelessly control an accessory flash that isn't attached to the camera using pulses of light to send instructions to the flash before the actual exposure. You can create stunning effects with wireless flash. See the Accessory section for more.

Section B: Viewing the Images

ON-SCREEN PLAYBACK

By default, each image you capture appears on-screen for two seconds. You can change this Auto Review setting to Off, 2 seconds, 5 seconds, or 10 seconds in the Custom menu.

To see the images after this display goes off, or at any time, press the Playback button—the last button left of the Alpha's LCD screen. You can use the left and right arrows on the Controller or the Control dial to move to the previous or next shot.

To zoom in, press the AEL button. There's a small blue magnifying glass with a plus mark in the middle just above and left of the AEL button. Pressing this button repeatedly will zoom in on your image up to twelve times. Once you've zoomed in, you can use the Controller to move around the image. A thumbnail of the image appears in the upper-right corner, and a small red box shows where you are currently zoomed in the main window.

Once you've zoomed in on an area, you can use the Control dial to switch between images, while remaining zoomed into the same spot. This is a great feature for checking focus and exposure in a series of photos.

You can zoom back out using the EV/AV button, also marked with a magnifying glass. Zooming out when in full-screen view takes you to the nine-thumbnail view. Here you can navigate among images in a given folder, or press the left arrow until the Folder icon on the left of the screen is highlighted. Press the OK button and a dialog box comes up allowing you to choose another folder

whose images you want to peruse. (See Setup Menu 2 to learn how to create additional folders.)

SLIDESHOW

The Sony A300/A350 offers a simple slideshow mode, available under the Playback Menu 2. Use the Controller to select Slideshow, press the OK button, and the slideshow will begin with the default settings, starting with the first image on the card. Press the OK button again to pause the show, and press the shutter button halfway to stop the slideshow. You can also use the left and right arrows to speed through the slideshow. If you don't press these buttons, the slideshow fades in and out pleasantly between shots. You can set the display interval to 1, 3, 4, 10, or 30 seconds.

ERASING IMAGES

To delete the image you're viewing, press the button that's just above the Playback button and is marked with a blue trashcan icon.

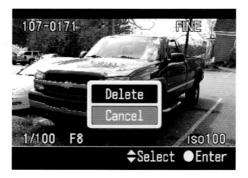

Press the Erase button to bring up the delete dialog. Use the up arrow to select Delete and press OK to confirm.

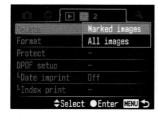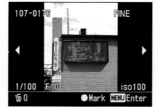

To delete more than one image, access the Menu while in Playback mode and select the first option in Playback Menu 1: Delete. Press the OK button, and a pull-down menu will appear. Here you can choose to mark images for deletion, or to delete all images. If you choose the Marked Images option, you enter Playback mode and you can mark images for deletion by pressing the OK button. Once an image is marked for deletion, a green trashcan icon appears in the center of the screen. To delete the selected images, press the Menu button. You'll be asked if you want to

delete the marked images. Press the up arrow on the Controller to select Delete and press the OK button.

INFO AND HISTOGRAMS

There are four information display modes available on the Sony A300/A350. The first shows a full-screen image plus basic recording information, including folder number, frame number, resolution and quality, shutter speed and aperture, date and time, ISO setting, and the image number/total number of images.

The second display adds some more information, plus four histogram displays (see the following section, which contains an explanation of histograms) to the right of the screen. New information includes exposure mode, exposure and flash compensation, metering mode, focal length, Color Style mode, white balance setting, and DRO mode. The four histograms cover overall luminance, and there are dedicated scales for red, green, and blue channels. Finally, over- and underexposed areas flash in the thumbnail image. This is a very informative view.

The third display shows the main image with only the exposure information across the bottom, and five thumbnails across the top. The five thumbnails include the displayed image, which has an orange bar across the bottom. Use the left and right arrows to select another thumbnail.

This view can be helpful when capturing a series of images whose color you're trying to get just right, for example.

Explanation of histograms

A photographic histogram is a very valuable tool. There is no "right" histogram that you should be seeking, but a histogram can tell you a lot about your image, including whether you have the exposure you want.

A histogram is a graph of the tonal values that your camera's sensor has captured. They are actually 256 tones, numbered from 0 to 255 (zero is included in the count of 256 tones). On the left are the darker values, starting with black (0), and to the right, the lighter values, ending with white (255). In the middle, the value is 128. In general, if your histogram shows a whole pile of data bunched up on the left, it's probably an underexposed image. If everything's off to the right, it's likely overexposed. If there are highlights that are "blown," or white with no detail, the pile on the right will appear to stack up against the edge on the right. Again, it's not wrong, but it might indicate an overexposure in your image. The same goes for the left side of the histogram.

When you set the display mode on your camera to the more detailed information display, you'll find four histograms, one each for Luminance, Red, Green, and Blue. They each have their purpose. The Luminance is showing you the overall values of each recorded pixel, regardless of color. Red, of course, is showing you the red values per pixel, again from 0 to 255, and so on for Green and Blue. The three color histograms are useful for what they can show you in terms of white balance. If one of the histograms has a pile of pixels that is skewed in a direction that's different from the others, such as if red is to the right, your image is likely to appear rather reddish. You might want to change your white balance setting at that point—or leave it if you think it looks like you want it to. Again, there's no "right" answer in a histogram, just information that you can use to improve your photographs.

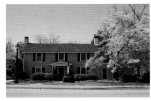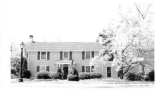

From left to right the images are exposed at −2EV, 0EV, and +2EV. Note how all the data in the first histogram is piled on the left, indicating a dominance of dark pixels in the image. The center image is well exposed, so the histogram is piled in the center, tapering off toward the ends. The image on the right is mostly bright pixels, so the data is concentrated on that side of the histogram.

VIDEO OUT TO TV AND PROJECTORS

Though it's something of a novelty, you can plug your Sony A300/A350 into a television and show the pictures via the camera's video out port. This is the port under the CompactFlash (CF) memory card door, which also serves as a USB port. The difference is the cable, included in your camera kit. Instead of a USB jack on the other end, it has an RCA video jack.

When you plug this into a television's RCA jack, the camera's LCD turns off and the menu display appears on the television screen. You can then use the Controller to move through the images in Playback mode, or start a slideshow to show them one at a time. The Sony A300/A350 functions the same when connected to a video projector. The key to using your Sony Alpha this way is remembering to bring the cable with you, and having a well-charged spare battery.

PRINTING IMAGES

Whether you plan to print at home, take your pictures to a store, or send your images over the Internet, the Sony A300/A350 can actually help you by letting you mark images that you want to print in advance. You can even print directly from your camera to a PictBridge-enabled printer (see the explanation later in this section) via a USB cable.

For those who have a computer and a photo printer, I recommend printing with your equipment rather than going straight from camera to printer. Though there are advantages to going from camera to printer, I think you gain more from saving your images to the computer, adjusting the occasional poor exposure and printing from there. You also have the benefit of looking at your pictures on a larger screen than your camera offers. That allows you to better see which pictures are worthy of printing, and which would be a waste of paper and ink.

DPOF PRINTING

The Sony Alpha features DPOF, which stands for Digital Print Order Format, a standard that allows you to select the images you want to print, including the quantity of each image you want printed. Many photo labs are DPOF-compliant, which means that you can enter your selections and then remove the card from your camera and hand it to the lab. See the DPOF explanation in the Menus section.

PICTBRIDGE

To facilitate printing directly to printers, many printer manufacturers use a standard called PictBridge. There will usually be a USB socket on the front of such printers, with a PictBridge symbol nearby, appearing like two opposing water drops. Just plug in the USB cable that came with your camera to make the connection, and then turn on the camera. You can

print only JPEG images via PictBridge; RAW images will not print this way. Here are the steps:

1. Make sure that your camera's battery is fully charged.
2. Change USB connection to PTP (found under Settings Menu 2).
3. With both the camera off and the printer off, connect the two with the USB cable. Power them both on.
4. The camera's screen will come on as usual, then it will go blank for about seven seconds. Next a PictBridge logo will come on-screen, followed by the most recent image that you captured.
5. Use the left and right arrows of the Controller to move between pictures, and press the Set button to mark an image for printing. A small printer icon will appear over the image, much like the images that mark images for deletion, protection, or DPOF.
6. When you're done selecting, press the Menu button. This will take you to the selection screen, where you can set print quantity, pick paper size, layout, and whether to include a date imprint. Then scroll back up to Print and press the Set button. Scroll up again to accept the print dialog box, and you're printing direct from camera to printer!
7. Don't forget to turn your camera off and unplug it so the battery doesn't run down while you enjoy your pictures.

Section C: Menus

The Sony A300/A350's menu system is very easy to navigate, with tabs that make switching between pages quite fast, and each item is explained in fairly plain language. Even when you're in the middle of a list, you can proceed to the next tab by pressing the right or left arrow; or, when you've reached the end of a list, and press the down arrow, the next menu tab is automatically selected. It's a smart system. Press the Enter button (the center of the Controller) to activate any menu item. There are some cameras on the market on which you press the right arrow to access menus, but that only moves you to another tab on the A300/A350, so you will have to unlearn that habit quickly.

RECORDING MENU 1

Press the Menu button in Record mode (any mode other than Playback), and you will be taken to Recording Menu 1. If you're in

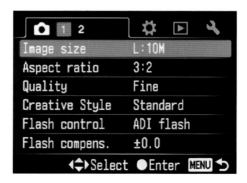

Playback mode, press the left arrow on the Controller until you arrive at this menu. Press the up and down arrows to select menu items, and press the center Controller button (marked AF), which serves as the Enter button.

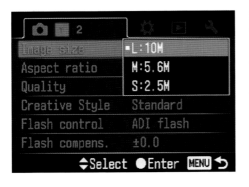

IMAGE SIZE

This item is highlighted automatically after you press the Menu button. Press the OK arrow to bring up your three options. The options you'll see depend on your chosen Aspect ratio (see following section), and the camera you have. If you have the A300 and have left the camera set to the default 3:2 aspect ratio, you'll be able to choose from the following options:
L:10M (Large, 10 megapixels, 3,872 × 2,592), M:5.6M (Medium, 5.6 megapixels, 2,896 × 1,936), or S:2.5M (Small, 2.5 megapixels, 1,920 × 1,280). If you opt for the 16:9 aspect ratio, your options are: L:8.4M (Large, 8.4 megapixels, 3,872 × 2,176), M:4.7M (Medium, 4.7 megapixels, 2,896 × 1,632), or S:2.1 (Small, 2.1 megapixels, 1,920 × 1,088).

If you have the A350 and have left the camera set to the default 3:2 aspect ratio, you'll be able to choose from the following options: L:14M (Large, 14 megapixels, 4,272 × 2,848), M:7.7M (Medium, 7.7 megapixels, 3,104 × 2,064), or S:3.5M (Small, 3.5 megapixels, 2,128 × 1,424). If you opt for the 16:9 aspect ratio, your options are: L:12M (Large, 12 megapixels, 4,272 × 2,400), M:6.5M (Medium, 6.5 megapixels, 3,104 × 1,744), or S:2.9 (Small, 2.9 megapixels, 2,128 × 1,200).

Press OK to select the new resolution setting, and press the Menu button or the Shutter release button halfway to return to Record mode.

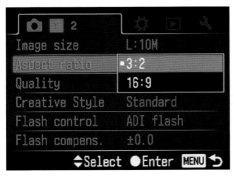

ASPECT RATIO

Aspect Ratio, the second setting on the list, allows you to choose between the sensor's actual size and the optional cropped mode, 16:9. This mode equates to the aspect ratio of most modern HDTVs, and produces files that are smaller in pixel count than 3:2 mode. Press the OK button to get the pull-down menu and press the Down arrow to select 16:9. Unless you have a particular reason to use this mode, I advise shooting in 3:2, because all you're doing is cropping the sensor's output—something you can do post-capture on a computer. Should you choose to use this mode, there are four horizontal lines in the viewfinder that delineate the 16:9 imaging area.

QUALITY

The Quality setting allows you to select relative compression ratios and whether to record RAW only or RAW plus JPEG images. If you plan to manipulate your images after capture *and* you have a large memory card, I recommend RAW capture; however, if you don't want to mess with image manipulation on the computer, stick with

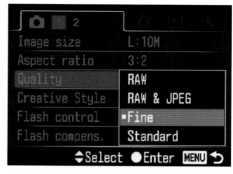

JPEG Fine. JPEG Standard compression introduces more error into your images, reducing image quality—and reduced image quality is not what you bought an SLR for.

CREATIVE STYLE

Creative Style sets the color mode for your images. You can stick with Standard or try out Vivid, Portrait, Landscape, Night, Sunset, Black and White (B/W), or Adobe RGB. If you're shooting RAW plus JPEG, feel free to choose any mode for your JPEG images, because you can always start over with your RAW images. If you're shooting only JPEGs, choose carefully. (See the earlier section on Creative Styles.)

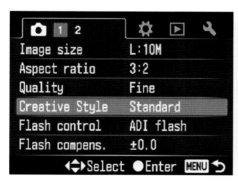
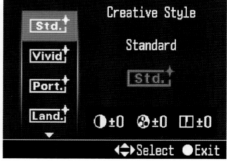

FLASH CONTROL

Here you can choose between ADI Flash control, which uses the lens's distance and aperture data in combination with preflash metering to set exposure, or choose just Preflash TTL (through the lens) to use preflash metering only.

FLASH COMPENSATION

Press the OK button to bring up the Flash Compensation scale, where

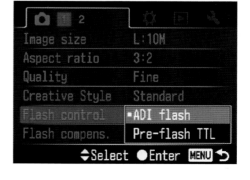

you can use the left and right arrows to adjust the on-board flash's output power by up to two stops above or below the default. The adjustment will appear on the detailed Status display, but not on the simple Status display.

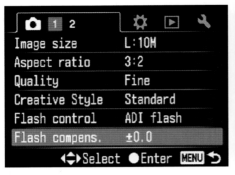

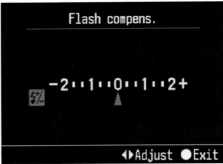

RECORDING MENU 2

Press the Menu button and then the right arrow on the Controller to bring up Recording Menu 2. Press the up and down arrows to select menu items, and press the center Controller button (marked AF), which serves as the Enter button.

PRIORITY SETUP

By default, the Sony A300/A350 won't fire unless it confirms focus. This is called "AF Priority." To force the camera to fire when you press the shutter release fully, regardless of focus status, change this option to Release. Press the Enter button to select.

AF ILLUMINATOR

On the Sony A300/A350, the pop-up flash serves as the AF illuminator by default, and it's activated automatically in full Auto modes. To disable this function, select Off. If this option is chosen, the camera does not fire AF-assist pulses, even when the Auto shooting mode activates the flash and the system needs AF assistance.

LONG EXPOSURE NOISE REDUCTION (LONG EXP.NR)

Enables noise reduction (NR) when the exposure is greater than or equal to one second. This mode delays your next shot by at least one second, because the camera first captures a one-second "dark" frame. It uses the noise it finds in this frame to subtract equal amounts of noise from the captured image to significantly reduce the noise in the image.

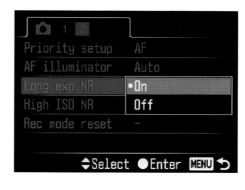

If you have the time, this is a good option to leave on, especially when trying to capture night shots with lights against a dark background. Note that this noise reduction is not applied to images when you shoot in Continuous drive mode, or in Continuous Bracketing mode.

HIGH ISO NR

Performs noise reduction on images captured at ISO 1,600. If you plan to process your images on the computer, turn this option off, as your noise reduction software can often do a better job than the camera—especially if you give it more information to work with, noise and all. Note that this noise reduction is not applied to images

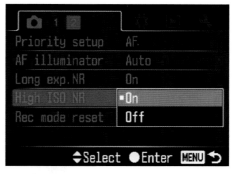

when you shoot in Continuous drive mode, or in Continuous Bracketing mode.

REC MODE RESET

To reset all record mode options to factory defaults, press the Enter button and then the up button to choose OK.

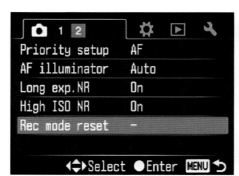
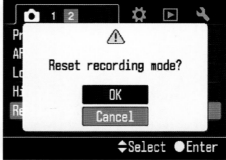

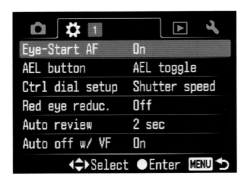

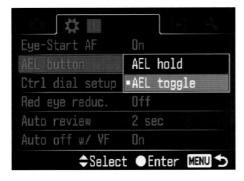

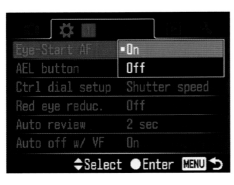

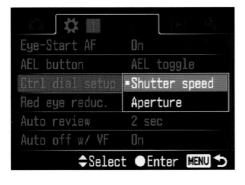

CUSTOM MENU

Custom menu is marked with an icon that looks like a gear. Press the Menu button, then the Controller button two times to bring up the Custom menu. Press the up and down arrows to select menu items, and press the center Controller button (marked AF), which serves as the Enter button.

EYE-START AF

When you bring the A300/A350 to your eye, by default the infrared sensor under the optical viewfinder detects an approaching object and starts up the Autofocus system. This very often does speed up autofocus acquisition. It can also drain the battery if you carry the camera by the grip at your side, for example, because the camera's AF system will come on often. Select Off to turn this option off.

AEL BUTTON

By default, you have to hold the AEL button to lock exposure. You can change this to lock the exposure with a single press and release. The exposure is then held either until you press the shutter release to take the picture, or you press the AEL button again.

CONTROL DIAL SETUP (CTRL DIAL SETUP)

In Manual mode, you have only one dial that can adjust either shutter or aperture settings. By default, the Control dial adjusts the shutter speed, and you have to press the EV/AV button on the back of the A300/A350 to set the aperture value. To reverse this behavior, choose Aperture from this menu and press Enter.

RED EYE REDUCTION (RED EYE REDUC.)

Red eye reduction mode fires a few pulses of light before capture to cause the pupils of your subject's eyes to constrict before the final exposure, reducing internal eye reflections that produce "red eye." Select Off to disable this function. This option is available only with the built-in flash.

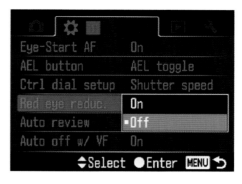

AUTO REVIEW

After you take a picture, the Alpha can display it for a few seconds for you to check it. Default is two seconds, but you can choose to have it display ten, five, or two seconds, or select Off to prevent it from displaying the captured image.

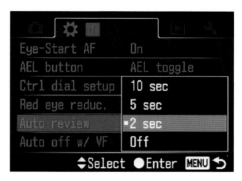

AUTO OFF W/VF

Because the LCD display can affect your vision when you're looking through the optical viewfinder, the Sony A300/A350 takes advantage of its infrared sensor to turn off the LCD by default until you pull your eye away from the camera back. The Status display remains off, and the Auto review of images does not begin until you pull the camera away to look at the LCD. If you want the LCD to remain on regardless, set this option to Off.

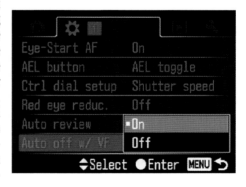

PLAYBACK MENU 1

When in Playback mode, pressing the Menu button will automatically bring you to this menu. If you're in Record mode, press the Menu button, then press the right arrow on the Controller three times to reach the first of two Playback menus. Press the up and down arrows to select

menu items, and press the center Controller button (marked AF), which serves as the Enter button.

DELETE

Before proceeding with the Delete option, note that if you delete images from your card *they will be lost permanently*. The camera offers no recovery method, and aftermarket recovery methods are of limited value if you continue to take pictures after the images are deleted, because new images overwrite the old ones.

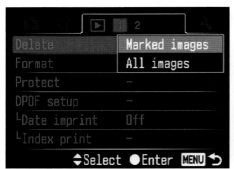
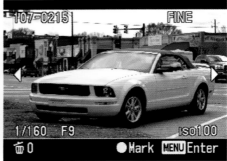

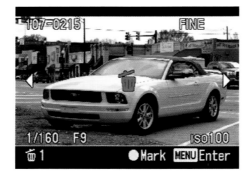

To delete images on the memory card, press the Enter button. You can then select the first option to begin marking images for deletion, or choose to delete all images. Either option asks for confirmation. If you choose to delete marked images, you'll return to Playback mode to see the images. Here you can press the left and right Controller arrows or the Control dial to scroll through the images, then press the Enter button to mark an image for deletion. A green trashcan icon will appear in the center of the screen. Use the arrows again to move to another image and continue making selections. Once all images that you want to delete are marked, press the Menu button and a dialog will come up asking you whether you want to delete them. Press the up arrow to select Delete and press Enter to delete. You cannot delete images that are marked with a Protect flag until protection is removed (see the Protect section).

FORMAT

Formatting your memory card completely erases all photographs, folders, and files from the card, including protected images (see the following section). Highlight the option and press Enter to format the card. Press the up arrow to select OK from the dialog that's presented. The card will be ready to receive new photographs. Formatting is a good idea after you've safely copied images off a card and onto a computer, but I recommend making a backup of those files onto a secondary hard drive or a CD or DVD before erasing the memory card.

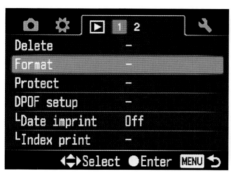

PROTECT

Use this option to protect images from accidental deletion from the memory card. You can choose to select images for protection by choosing the "Marked images" option, which takes you through a process similar to the Delete Marked images option mentioned earlier, or you can choose to protect "All images," which protects all current images on the card, but not newly captured ones. You can also choose to unmark all images, removing their protection flag.

DPOF SETUP

You can select images for printing with DPOF setup. DPOF, as explained earlier, is a standard for designating in advance the images you want printed, and what quantity you want to print. You can choose to print Marked images, to print All images, or to Cancel all DPOF settings. Working much like the Delete and Protect menu items, the Marked images option allows you to scroll through your pictures and mark them for printing

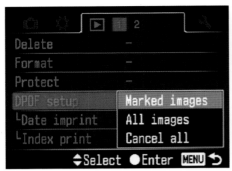

with the Enter button. Once you've marked them, you can press the zoom out and in buttons (the EV/AV and AEL buttons just right of the viewfinder) to increase or decrease the number of each print that you want. You can also select the All images option to mark all images for printing. You can specify a number of prints from one to nine, which applies to all selected images.

Date imprint

As an option under DPOF, you can add a date imprint to your printed images when printing via DPOF by setting this option to On. You cannot control where or how the date overlay looks, as it varies by printer; this option may also not be available on all DPOF printers. This does not affect the digital images on the memory card.

Index print

You can print an index of all JPEG images on the card (RAW images do not print). You have to update this index print when new images are captured. How many images print is dependent on the printer.

PLAYBACK MENU 2

If you press the Menu button while in Playback mode, reaching Playback Menu 2 is just a right-arrow-press away. If you're in Record mode, however, you'll need to press the right arrow four times to reach Playback Menu 2. Press the up and down arrows to select menu items, and press the center Controller button (marked AF), which serves as the Enter button.

PLAYBACK DISPLAY

The camera rotates images that were taken in vertical format automatically by default, thanks to its camera position sensor. You can choose to turn this off by selecting "Manual rotate," especially if you want to see the image at the largest size possible on the horizontally oriented LCD screen.

SLIDE SHOW

Select this option and press the Enter key to start a slideshow of all images on the card. Images fade in and out between slides. Use the Interval option (discussed next) to specify how long each slide displays.

Interval

You can set the image display interval to one, three, five, ten, or thirty seconds per image with this submenu item. Press Enter to bring up

the list and use the up and down arrows to highlight the item you want, then press Enter to make your selection.

SETUP MENU 1

To select Setup Menu 1, it's easier to press the Menu button and press the left arrow three times; alternatively, you can press the right arrow five times to get there as well. Press the up and down arrows to select menu items, and press the center Controller button (marked AF), which serves as the Enter button.

LCD BRIGHTNESS

To adjust LCD brightness, highlight this menu item and press the Enter button. A graphical display comes up showing several gray boxes and a scale that covers five settings. Choose your setting and press the Enter button. You can raise the brightness outdoors to better see menu times, but be aware that it affects how you see images, and could result in over- or underexposure. Be sure to check your histograms in these situations.

INFORMATION DISPLAY TIME (INFO.DISP.TIME)

The Status display times out after a preset interval; you can set this interval with the Information display time menu item. Press Enter to see the list, which includes five, ten, and thirty seconds, and one minute. Use the up and down arrows to highlight your selection and press Enter.

POWER SAVE

The Sony A300/A350 enters a low-power mode after a few minutes of inactivity. Use the Power save menu item to set the interval before this happens. Options are one, three, five, ten, and thirty minutes.

VIDEO OUTPUT

When using the audio cable, you can plug the camera into a television

with an RCA jack. In North America and South America, set the Sony A300/A350 to NTSC. Abroad, the only other option is PAL. These are two of the broadcast standards that televisions use in various countries.

LANGUAGE

Menus can be displayed in several languages, including English, French, Spanish, Italian, Japanese, and Chinese. Use the up and down arrows to select a language and press Enter to select.

DATE/TIME SETUP

When you first turn on the A300/ A350, you'll find the Date and Time dialog, which is the same one that you find if you select Date/Time setup and press the Enter button. Use the left and right arrows to

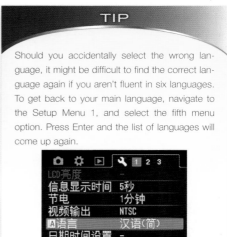

select a field that you want to change and the up and down arrows to make changes. Press Enter to save and return to the menu screen.

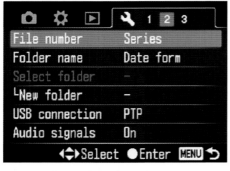

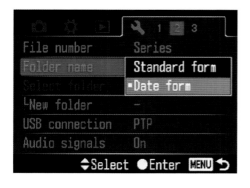

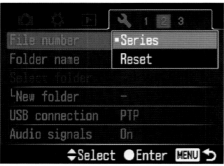

SETUP MENU 2

To get to Setup Menu 2 quickly, press the Menu button and press the left arrow twice. Press the up and down arrows to select menu items, and press the center Controller button (marked AF), which serves as the Enter button.

FILE NUMBER

By default, image file numbering continues until it resets after capture of 9,999 images, regardless of the folder name or the card used. You can keep this option at the default by leaving this menu item set to "Series," or you can change it to "Reset." Reset restarts the number sequence each time the folder format is changed, when all images are deleted, when the memory card is replaced, or when the memory card is formatted. To avoid overwriting recent images, be sure to copy new images into folders with a different name if copying manually, or leave the default setting of "Series."

FOLDER NAME

The default folder name, called "Standard form," is a three-digit number followed by "MSCDF." The first one that the camera generates is 100MSCDF. If you choose "Date form" from this menu, the camera builds a folder name based on the folder name and date. It will still increment from 100, or the last folder number you created, but it will also include the date, making a new folder for each day you shoot. For example: Folder number + Y/MM/DD results in 10081023 for a folder created on October 23, 2008. After a bit of trial and error, I've decided upon this method, because it automatically separates images by date.

SELECT FOLDER

To switch between folders, highlight the Select folder item and press the Enter button. A small dialog will come up, and you can use the up and down arrows to choose a folder. Press the Enter button to select.

NEW FOLDER

To create a new folder, highlight New Folder and press Enter. A new folder is created in the Standard or Date form, depending on the Folder name option's settings.

USB CONNECTION

To connect the camera to a computer, set the USB connection option to Mass Storage (default). In this mode, the camera appears as a hard drive on the host computer. To connect directly to a printer with the USB cable, select PTP (picture transfer protocol).

AUDIO SIGNALS

The A300/A350 beeps when focus is achieved and while the Self-Timer is activated. To turn these sounds off, select the Audio signals option, press Enter, move the highlight to Off, and select Enter again.

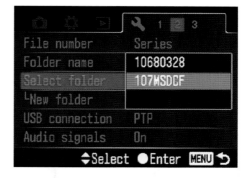

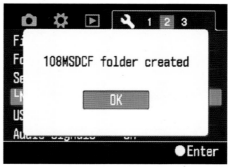

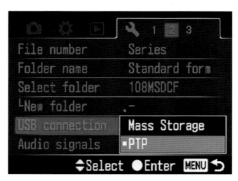

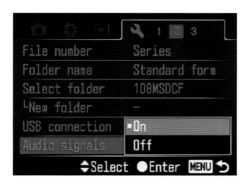

SETUP MENU 3

To quickly reach Setup Menu 3, press the Menu button, and press the right arrow once. Press the up and down arrows to select menu items, and press the center Controller button (marked AF), which serves as the Enter button.

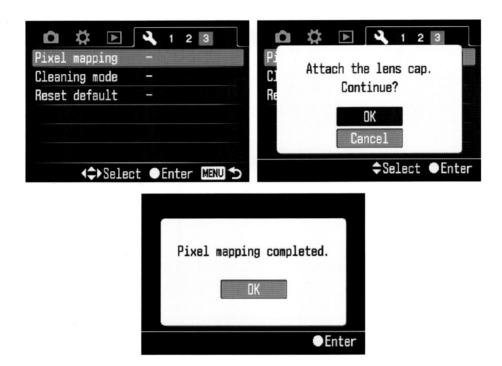

PIXEL MAPPING

Pixel mapping is a technique used to find and compensate for dead and malfunctioning pixels on a sensor. This menu item does not appear on the Sony A200, but not because its sensor doesn't need pixels mapped; it's because this function maps the Live View mode's sensor, not the imaging sensor in the A300 and A350. If you start to notice hot pixels on the LCD when working with Live View mode, hit the menu button and try the Pixel Mapping menu item. Attach the camera's lens cap, hit the up arrow to select OK, press the OK button, and wait while the A300/A350 remaps the sensor. It should only take a few seconds, then press OK again to resume shooting.

CLEANING MODE

Cleaning mode lifts the mirror and opens the shutter, exposing the sensor for easy cleaning. If you start to see dust in your images, it might be time

to clean your sensor. This is no small undertaking, so follow the cleaning instructions carefully, and look into a good cleaning solution. Or take the camera into a camera store to have the procedure done. Regardless of what cleaning method you decide upon, it will involve opening the mirror and shutter mechanism, exposing the top sensor glass. (See the Sensor Cleaning section.)

RESET DEFAULT

To reset all Setup items to their defaults, highlight this option and press Enter. Then press the up arrow to highlight OK and press Enter again.

Section D: Memory Cards, Batteries, and Maintenance

CARD CHOICES

Your Sony camera is compatible with a widely used memory card format called CompactFlash (CF, as mentioned in passing earlier). Because it's one of the oldest small memory formats, and because it's a little larger, CF cards are generally less expensive than other options in the same capacity, so you can often get larger cards for less money than other formats.

The CF card comes in two size types: Type I and Type II. Type II cards are more rare today, but Sony sells a Memory Stick Duo adapter (AD-MSCF1) that is a Type II card. Though this is a good option if you already have Memory Stick Duo cards, CF cards are generally less expensive than Memory Sticks. You might also want this adapter if your computer or peripheral exclusively uses Memory Stick Duo cards.

SanDisk Ultra II is a good safe bet in CompactFlash cards. Always insert the card with the fifty little sockets facing in toward the camera.

Another common Type II card is the Microdrive, which is actually a miniature hard drive, originally designed by IBM, but currently manufactured by Hitachi. When memory chip prices were high, the Microdrive made economical sense, but most high capacity CF cards are cheaper than equivalent Microdrives. Microdrives also use more power than solid-state CF cards, and are more likely to be damaged if they're dropped.

CARD BRANDS AND SPEEDS

When it comes to CF card brands, there is a bewildering array of choices, and many boast very high speeds. The truth is that results vary by brand and quality. In general, I recommend sticking to brand names purchased from a reputable retailer. Stick with brands like SanDisk, Lexar, Kodak, Sony, Delkin, Kingston, Crucial, and PNY.

Get the fastest and largest card you can afford (within reason). If you plan to shoot RAW images, be sure to get at least a 4GB to 8GB card, and it would be wise to pick up more than one. Because the Sony A300/A350 does not support UDMA (Ultra Direct Memory Access, a high speed memory addressing protocol), you don't need anything like a 266x or 300x memory card, because the camera cannot use all that speed. It's probably limited to 133x write speed, so to save money, stick with something of that speed rating or a SanDisk Extreme III.

Of course, your computer might be able to use that speed, so if you get a fast card reader, it might still be worthwhile to choose a very high-speed card, as offloading your images can be tedious if you use a slow card or connection.

CARD CARE

Keep your CompactFlash and Memory Stick Duo cards in a cool, dry place, and don't let them sit in sunlight. If they're stored in a camera bag, keep them in a case that won't let them fall out easily. They're fairly durable, but it's best not to drop them. The fragile memory chips inside can become dislodged, and the very precise socket positions on CF card can move if the drop deforms the plastic and thus bends the pins inside your camera.

It's also good to format the cards frequently, but only in the camera you intend to use them with, as computers can format them in a way that the camera cannot use.

CARD READERS

Although there are many different kinds of cards out there, there are only a few card readers that are worthy of your money. SanDisk, Lexar, and Kingston make readers worth consideration.

A reader like the Lexar Professional UDMA CF SD Reader uses USB 2.0, and can read both CF and SD (Secure Digital) cards. It retails for approximately $45. Its ports are protected by a pop-up design—something that's hard to under-estimate when you consider what a card reader can encounter in a camera bag that might damage the reader's CF pins.

Lexar's Dual Slot reader folds up to protect the slots. Despite the image, don't put a card in each slot at the same time.

If you want to get something faster than USB 2.0, you can look into the Lexar Professional CF Reader for FireWire 800. You have to make sure that your computer has a FireWire 400 or 800 port to take advantage of this speedy reader. This reader retails for around $75.

The SanDisk Extreme CF USB 2.0 Reader is designed to support the company's new 30 MB per second CF cards; no price was known at press time.

If you're looking for a decent multi-card reader (one that will read many different kinds of cards), look into the Kingston USB 2.0 Hi-Speed 19-in-1, which also retails for around $25. Among others it can read CompactFlash Type I and II, Secure Digital, miniSD, microSD, MultiMediaCard, MMCmicro, MMCmobile, MMCplus, RS-MMC, Microdrive, Memory Stick, Memory Stick PRO, Memory Stick PRO Duo, and SmartMedia.

These ultra-fast Lexar Professional readers can snap together and read in parallel for rapid offloading from several cards at once.

SanDisk Extreme CF USB 2.0 Reader

Kingston's 19-in-1 reader supports almost every standard but xD.

BATTERIES

The Sony A300/A350 uses the NP-FM500H, a 7.2 V 11.8Wh lithium-ion battery available for approximately $60. Batteries from the A100 (NP-FM55H) are incompatible with the Sony A300/A350, but the new battery is backward-compatible with the A100 camera. If you plan to shoot a lot, it's wise to purchase at least one spare battery for your Alpha. Rechargeable lithium-ion batteries are legendary for their long shelf life, so a fully charged battery will still be usable even after several months in the camera bag.

Sony's Infolithium battery has the brains that other brands don't, allowing for more accurate battery level reporting; unfortunately, this does make them a little more expensive.

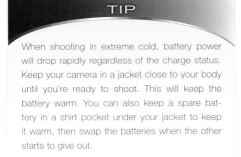

TIP

When shooting in extreme cold, battery power will drop rapidly regardless of the charge status. Keep your camera in a jacket close to your body until you're ready to shoot. This will keep the battery warm. You can also keep a spare battery in a shirt pocket under your jacket to keep it warm, then swap the batteries when the other starts to give out.

When storing your batteries, be sure to keep the included plastic cover over the contacts to avoid a fire. These batteries have quite a bit of power in them, enough to ignite a fire in your pants if the metal electrical contacts touch your keys or other metal objects in your clothing or camera bag. Lithium-ion batteries can be quite volatile, so be mindful of how much energy is stored in their seemingly innocuous plastic bodies.

Also, do your best to never drop your batteries. Dropping a battery is an easy way to say goodbye to $60, because they don't take shock well. If you drop one and it suddenly can't hold a charge for very long, it probably needs to be replaced. Also, like the memory cards, the plastic casings can deform in a fall such that the battery won't fit into your camera; or else, if it fits, it might not come back out for charging. So dropping the battery is definitely good to avoid.

CHARGER

The Sony A300/A350 comes with a battery charger and a power cord. It's fairly simple to use. Just plug in the charger, remove the battery from the camera, place it in the charger about three millimeters from the contacts,

and slide the battery toward the LED light on the top deck. The LED will light while charging, and go out when charging is complete.

AC ADAPTER

Available as an optional accessory, the Sony AC-VQ900AM AC/DC adapter and battery charger will charge two NP-FM500Hs or power the camera via an included cord, which connects to the camera's DC-in port on the left side of the camera. Batteries are charged one at a time, in sequence, but you get a little more feedback with this device than you get from the charger that's included with the camera, including "time remaining" charge status display. You can't charge and power the camera at the same time, so it's a multipurpose charger that can only do one thing at a time. MSRP: $129.

CAMERA CLEANING

Cameras are precision instruments with tight-fitting parts, so keeping them from dust, grit, and moisture is critical. It's also nearly impossible. You need a strategy to clean your camera between uses, and that includes a few inexpensive items available online or at your camera store:

1. Microfiber cloths (different colors, if available)
2. Blower brush
3. Blower bulb
4. Lenspen (www.lenspen.com)

You can also get the more traditional lens cleaning cloths, lens cleaning solution, and a can of compressed air, if you like, but you can do most of what you need with the listed four items.

There are a few simple steps to cleaning your digital SLR:

1. Use the blower brush or blower bulb to blast dust and lint off the surfaces of your camera. Hold the camera up, and blast at it from underneath, so that dust removed will fall away, and not land back on another camera surface. Be sure to get inside the optical viewfinder and other deeper areas, and work around the lens as well. Work the lens and blow a little more softly, so as not to force dust into the lens workings. You just want to blow them away, not deeper inside the camera. If you use a blower brush, be careful not to let the hairs get caught in tight spaces.
2. Use a microfiber cloth to softly clean the lens elements and the optical viewfinder. Use a separate microfiber cloth to wipe the LCD screen clean and to brush the dust off the remaining surfaces. Try to keep these two cloths separate. Open the CF card door and clean under the door. Carefully remove the lens and wipe the metal lens mount, being careful to keep the camera's body facing down to keep dust and debris from falling into the camera body. Put the body cap on the camera (first make sure that it's clean).

3. Use your "body" microfiber cloth to wipe the lens mount surface, and switch to the "lens" microfiber cloth to wipe the inner lens, but only if it's necessary. Don't touch any lens surface unless it needs cleaning. The less contact the better.

4. Follow the instructions for the Lenspen, which itself includes a short lipstick-style lens brush. Extend the soft bristle brush and knock any remaining dust free. If there are fingerprints or other marks on the lens, spin the cap on the Lenspen's other end and then remove it. Gently place the Lenspen's special black tip onto the lens and move in a circular motion across the lens surface. If the marks remain, blow on the lens to steam it up a bit and use the Lenspen again. Be sure to follow the current instructions on the Lenspen box.

5. Once you're satisfied with your cleaning job, reassemble the camera and put it away in a soft or hard camera bag or box.

SENSOR CLEANING

There's no getting around it: your sensor will eventually need cleaning. Cleaning your own sensor is a big undertaking, so don't just jump in with both feet. Read up on the procedure and weigh your options carefully. Your camera does indeed "clean itself," but that only works so well. There are too many types of dust for any current cleaning system to knock everything loose, as nearly any material can be reduced to dust and set afloat in the air.

The simplest method, and first line of offense against dust is to use the blower bulb outlined here to blast the dust off your sensor:

1. Start with a fully charged battery (it won't work without at least three bars showing on the battery indicator).

2. Highlight the Cleaning mode button and press Enter. The mirror will lock up and the shutter will open.

3. Press the lens release button and remove the lens with a twist to the right. Be careful to aim the camera down at this point.

4. Use the blower brush to blow the sensor clean from a distance. Blow only from outside the mirror chamber. Blow across the sensor from the four corners. Don't touch the sensor with the blower brush! And don't let anything touch the sensor glass.

Alas, this method may not dislodge all particles, in which case you'll have to physically clean the sensor. There are a lot of products designed to do this, from static brushes to swabs and even adhesive patches that aim to grab the dust while not marring the sensor. The best method I've seen so far, and the one I use, is the Copper Hill Method, which includes a SensorSwipe and the pads and solution to go with it. Visit their site

The CopperHill Method is my preferred cleaning technique, available online for around $30. It's not just the materials they provide, but the detailed tutorial that makes cleaning your sensor straightforward. It's also quite effective.

(www.copperhillimages.com) and get one of the basic kits for $29.95, or pick another bundle. Follow their instructions and you'll do just fine. I was appropriately nervous on my first try, but I'm more confident after a few times.

The Software

Sony Software;
Sorting and Storing Your
Images;
Backing Up

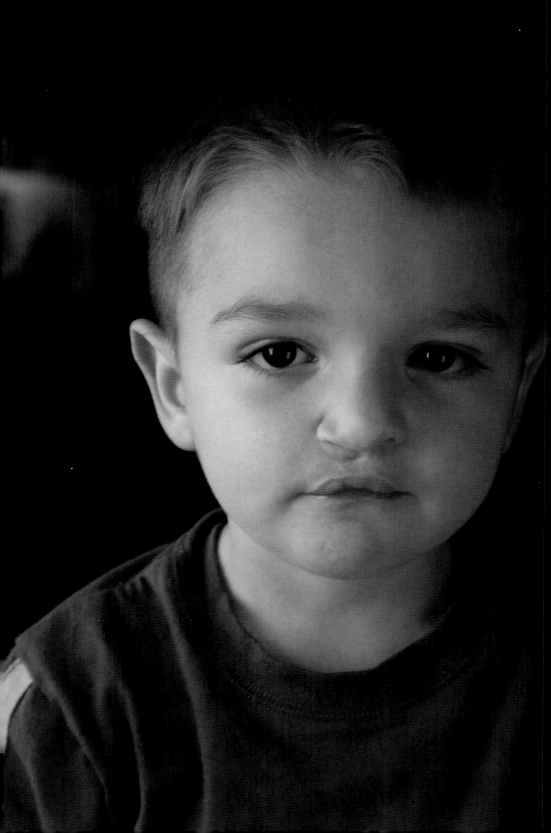

Sony Software

Sony bundles three applications for Windows users, and two applications for Mac users. The Picture Motion Browser, an image sorting and editing program, is for Windows users only, and the Image Data Lightbox SR and Image Data Converter SR, both used for RAW processing, are for Mac and Windows users.

I've been telling you throughout this book to shoot RAW images if you are in doubt about a shot; here I'll introduce the concepts necessary to manage and develop those RAW files. RAW files represent the data that the sensor captured, and are saved without any processing. You can therefore make your own selections on a whole range of choices, including white balance, color mode, hue, saturation, DRO mode, and many others. But first, you need to install the software.

Just take the CD out of the bright orange envelope and carefully insert it into your computer. Follow the on-screen instructions. Mac users must double-click the disk icon that comes up on the desktop, then double-click the MAC folder. Finally, double-clicking *SIDS_INST.pkg* will launch the install program.

PICTURE MOTION BROWSER

Picture Motion Browser (Windows only) is a catchall application for all digital camera–generated media, including both still photos and videos made on Sony digicams.

I thought about messing with the colors in this image, but decided that I liked muted color with the muted expression. If you look into his eyes, you can see the window light on the left and the white card on the right, providing beautiful, natural fill.

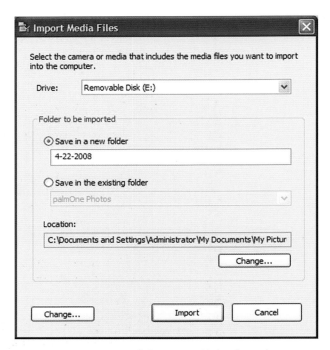

The Import Media Files dialog prompts you to specify how you want to handle your images.

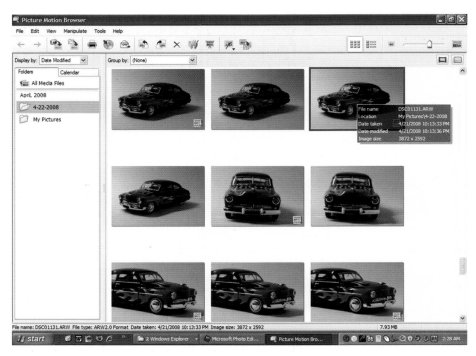

Picture Motion browser performs common file management functions, as well as simple editing.

When you insert a memory card into a reader or plug your camera into the computer, a dialog box called "Import Media Files" pops up. Unless you have a specific folder in which you want to save the images, select "Save in a new folder" and let it store images under the date they are going to be uploaded.

Picture Motion Browser lets you play slideshows and videos, save images to disks, view images by calendar date, print images, and even relate your images to locations on a map when you have recorded GPS data in your images.

Picture Motion Browser can also manipulate your JPEG images, either automatically or manually, to correct color, saturation, and contrast; remove red eye; correct tone curves; trim images; and even add a date to your images. The program comes with a text guide to its features that is worth exploring.

Picture Motion Browser can show your RAW images as thumbnails, but it cannot edit them. For that, you need the next two programs.

IMAGE DATA LIGHTBOX SR

The Image Data Lightbox SR program (Lightbox for short) allows both Windows and Mac users to view, rank, and convert RAW images to JPEG

Image Data Lightbox SR allows you to display and stack thumbnails of your RAW and JPEG images; it also batch-converts images. Here I've chosen *DSC01131.ARW*, which I deliberately underexposed by −1.0EV to demonstrate why shooting RAW can be an excellent form of insurance.

or TIFF. It can also batch-process the images. Lightbox works in concert with Image Data Converter SR to allow you to stack multiple versions of the same RAW file for easy referral, storage, and conversion.

IMAGE DATA CONVERTER SR

The real action happens in Image Data Converter SR. An impressive range of controls makes RAW adjustment and conversion easier than it is in many high-end programs. I'll take you through one scenario to give you an idea of what the software can do. I won't cover every adjustment, but you'll get the idea and can then explore on your own.

When you first open the program, especially in Windows, Image Data Converter SR seems like the least intuitive program for image editing, as it overlays the image you've opened with about seven control windows. It's as if the program doesn't want you to miss all of its features. Unfortunately, you can't see the image you're trying to adjust until you close all the windows and shrink each palette down to its titlebar. If no control windows appear, go to the Tools and Palettes menus.

Close all the subtopics by pressing the arrow to their left, and open them only when they're needed. Here I've opened the EV control and made an adjustment.

Switching to Mac (for its wider screen, in this case), you can see that the histogram is telling us that the image is underexposed, because there is no data in any of the lighter range, which is off to the right. Also note that the various controls are grouped together. It's better to make your adjustments in the order of Adjustment levels.

If I open the White Balance option, I can change the white balance to one of many options. If I set it to Shade, note how the blue, green, and red histograms separate, and the color changes dramatically. Had I adjusted the Exposure Value first, they might have no room to spread into, and some of the data might have clipped—notably the red channel. This again is why you want to make most of your adjustments by group before moving on to the next group

Just for fun, let's tweak the Hue setting. Because it's a black car, most of the color change occurs in the flames, and the difference is surprising.

After resetting the Hue to normal, I close the Adjustment sublevels and open the Adjustment 2: EV Adjustment menu. As I know I underexposed the image by −1 EV, it's not a surprise that it needs about a +1.0EV adjustment to come back to normal. Note how the histogram expands to fill that gap on the right side.

Because I'm sitting here with the car in the same light that I used when I shot it, I can see that the black is far richer than I see on-screen, so I grab the Contrast slider and increase it to +37.

DRO adds a little more punch, lightening the background and even some of the car again, but the effect is greater contrast where it matters.

Then I open the Saturation control to put some punch in those flames.

The finished product. With all my adjustments made, I hit the Photoshop link button, which transferred the image to Photoshop, where I removed the dust and other imperfections on my toy 1949 Mercury. The end result is not far from the original.

Sorting and Storing Your Images

SORTING

To sort your Sony Alpha images, I recommend changing the folder name option (in the Settings 2 Menu) to Date Form, so that a new folder is created for each day you take pictures. Then you can just grab that batch and copy it to a folder on your hard drive, with no intervention from software at all. If you have a Windows computer, the Picture Motion Browser will do it all for you. I just sort mine in folders by day, in a larger folder by year. If you want greater control, just create subfolders under the year and name it with the number of the month followed by the event—something like "04-Birthday" for all the birthday pictures in April.

There are dozens of programs designed to better sort your images and make cataloging and retrieval easier. One of the best is also a great photo editor with professional pedigree: Adobe Photoshop Elements 6, available at www.adobe.com.

Be careful what you pick, though, because programs change and companies go out of business. The last thing you want is to have your images spread across several programs that promised to organize your collection.

Backing Up

Though I often suggest shooting a lot and shooting in RAW when in doubt, there is a price if you want to keep all those images: disk space.

As we accumulate digital images and discover digital delivery and storage methods, we make fewer prints. That's great for limiting the number of boxes in the basement, but though digital images are more compact than a stack of prints, they can be lost in a blink. Hard drive failure is the most common cause of image loss; accidental formatting is another. But even if the mechanism stays intact and you don't delete the data, magnetic media fades over time.

Though many of us were taught that CDs and DVDs are indestructible and last forever, that's far from true. The maximum expected life of a CD or DVD that you got on sale is five years. You can buy archival-grade disks, but there are no guarantees that your data is safe. You can increase the likelihood if you store them properly: In jewel cases, standing vertically, and at reasonable room temperatures, out of direct sunlight.

STANDARD PROCEDURE FOR SAFE DATA
MAINTAIN TWO COPIES

When you come home with your pictures, copy the images from the camera or card onto your hard drive. Do not format or erase the card. First, make another copy of the files, even before you look at them. If you have an external hard drive, copy them there. If you have only a recordable CD or DVD, copy them there. Look at a

few images to make sure they open. Then you can feel safe formatting the memory card.

I keep my latest pictures on my main hard drive, and burn them to a disk. Then I transfer them to a backup storage drive every month or so, or when my main hard drive starts to fill up. I keep this drive turned off until I need it. I have another drive that I keep either at the office or in another room, which I take out periodically to grab the latest images.

It's not that expensive to be redundant in your backup and storage strategy, and it offers peace of mind.

Upgrade and re-copy

To keep the magnetic data from fading on your hard drives, it's not a bad idea to copy images from one drive to another to refresh the data. It's better to use a new disk, especially if you left the old one on all the time. It's wise to buy a new disk every year or two, if possible, and continue this image shuttling game to keep those ones and zeros in top form.

ONLINE STORAGE

Don't forget about online storage services. Some just take your images and lock them away. Others make them available on a site for your friends and family to see, download, and print; all at your convenience. Sites like phanfare.com and smugmug.com host your images for a fee; others, like Google's picasa.google.com host your images for free. Phanfare accepts your full-size images, processing them down to Web-size.

But you can always go back and retrieve your originals, which can be helpful if you have a hard drive failure or lose some CDs.

OFF-SITE STORAGE

If storing your images online is out of the question, consider storing a set of disks off-site, by taking a set of backup disks to your office or a safety deposit box for safekeeping. This step protects against loss due to flood or fire.

Whatever you do, be redundant to make sure that you're saving your images for future generations.

The Light

Using Natural Light for Effective Pictures

Using Natural Light for Effective Pictures

The dramatic moments in our lives are most often lit naturally, so capturing those moments effectively requires learning about natural light photography. Natural light isn't limited to sunlight, candlelight, and campfires; it's the light around us that comes from lamps, windows, computer screens, headlights: all the light sources we're used to seeing illuminate the world around us.

The most common alternative to natural light is on-camera flash, which has to be one of the most unnatural light sources available. It's not the light itself that's so unnatural, but the direction it comes from that ruins the natural feel of a flash shot. It doesn't appear like any lighting we're used to seeing in the real world. After all, none of us walks around with a big bright light mounted on our heads to front-light everything we see, except perhaps mineworkers and television camera operators. But that's what most flash units do: they fire a big burst of light at our subject, filling in most shadows, and creating a few of their own, usually behind the subject.

If you want your photos to look more natural, there are a lot of great tricks that you can use. Some of them will actually involve flash, believe it or not, but used in a way that most snapshooters don't think of. Most of the techniques covered here are possible with little or no equipment at all. Your camera and the materials available in most households will serve just fine. There are many

Photography by candlelight is possible with the A300 and A350's ISO 3,200 setting and Super SteadyShot stabilization. This shot is a little soft and grainy, but that adds a certain charm.

natural light techniques, and many types of natural light, but I'm going to go over only a few simple ways to get good shots with the light around you and very little effort on your part.

INDOORS

Indoors is where most of us need help taking better pictures. It's so easy to just leave it in Auto and let the flash fire where it may. But it's not just the exposure system that struggles indoors; the AF system also needs a little help. Most people don't realize how much darker it is indoors than out. If you're trying to force your camera to take a low-light picture in the middle of your house, you're giving it too much of a challenge. My first solution addresses both of these problems, and will not only help you get better pictures—they'll look like photographs you meant to take.

WINDOW LIGHT

The light coming through your window is so much brighter than the light in the middle of most rooms. You don't want direct sunlight, just light reflected from the outside. It's soft and diffuse—perfect for nice portraits. Provided that there's room in your home, just move your subject to a window and slide over next to the wall yourself so the light is hitting half of their body. Some homes are cramped, so it won't be possible everywhere,

I'd been searching for a restaurant with a single window to demonstrate this simple portrait technique, but the only one open consisted of windows on three sides. Though I brought my white card to demonstrate fill light, I ended up using it to block some of the light from one window to add a little more depth to her face. Exposure: f/2.8, 1/400, ISO 200.

and you may need to move furniture around, but it's usually pretty easy to get near the window. I've even used restaurant windows, as they're usually large, and there are plenty of chairs around to help pose your subject.

If the window light is too bright and is creating shadows that are too harsh, I keep some white foam-core posterboard on hand to use as fill light (you'll find it at most office supply stores). The window light almost always includes enough light for that simple reflector to serve as good fill. It helps to have an assistant off to the side to help hold it just right.

From there, adjust your aperture to one appropriate for portraits—say f/2.8 to f/5.6, depending on the light, the background, and the depth of field of your lens. Make sure that your shutter speed is easily handheld; above 1/60 second is a good, safe starting point. Try to use ISO 100 if possible, and adjust it upward if you can't get a shutter speed that works handheld.

SIMULATED WINDOW LIGHT

Lacking window light, you can simulate it with a lamp and a piece of vellum or other translucent white material that diffuses light. The trick is to have a large surface area to simulate that window light. An art store will have the right material, and you can also use ceiling-mount fluorescent light panels available from the hardware store. You'll have to be sure to set your white balance to match the source, preferably with a custom setting rather than a preset. Window light can easily influence your white balance if your source is a lamp, so close your blinds and curtains if you try this.

The Lowel Ego provides a nice, soft light, great for product photography and portraits.

There are commercial products on the market that also serve well. The Lowel Ego (www.lowelego.com) is a fluorescent lamp with a large surface that sells for less than $100 and is excellent for portrait or product lighting. It puts out a soft, diffuse light that can actually be relaxing for subjects. It's a lot better than flash for setting a subject at ease.

LAMPLIGHT

If there's a lamp that you can place in front of your subject, it can also serve as a mesmerizing light source. If you have two lamps, have one close to your subject's face, say on the right side, and the other off to the left, next to your shoulder, to serve as fill. As with all of these shots, you'll want to set your white balance manually, or use a gray card or WhiBal card in the scene when you record your first shot, so you have a reference.

If you like the light as it's striking your subject with the lamps in their normal position, just raise the ISO and start shooting. Be sure to zoom in on your images to make sure of your focus and stability. You'll likely need a tripod for light as low as this. Incandescent light can be quite yellow, and fluorescent lighting can be all over the spectrum, producing unflattering colors. It pays to look closely, and shoot in RAW mode when possible so that you can make changes afterward.

CANDLELIGHT

Here's where you trust your camera's meter and high ISO capability. Just raise the ISO to 1,600, set the camera to Center-weighted or Spot Metering mode, and take a few shots. You might also trust the camera's matrix

Here's an impromptu shot in a restaurant. The restaurant lighting was dim, but the candles were close enough to create a nice glow on the subject. For white balance, I trusted Auto Exposure: f/5, 1/25 second, ISO 1600.

metering mode and see what happens. Of course, if it's a birthday shot, you only have a short time, so set it up in advance.

Take care when setting the white balance. You could set the white balance really low, but then you'd end up with white light, instead of the nice orange or yellow glow that you want. If you'd like to save the decision for later, shoot in RAW mode, then set the white balance on the computer and make the final adjustments when you have more time.

You should be able to light your subject with just a single candle, but you can use as many as you like to get a wraparound effect. The more candles you add, the more light you have to work with, which means faster shutter speeds and better AF ability.

FLASH

As I mentioned earlier, the main problem with on-camera flash isn't its color or its nature: it's the angle that it approaches from that makes it seem so unnatural. Its relative proximity to the lens also creates an all-too-familiar problem: red eye. Move the camera off the flash, or bounce it from a nearby surface, and you change the nature of the light significantly.

Bounce

Bounce flash requires the purchase of an external flash, like the Sony HVL-F36AM digital camera flash. This external flash mounts on the unique Sony hot shoe on the top of the camera. This flash's head swings up so that you can bounce the flash off the ceiling—preferably a white ceiling—creating a softer overhead light than you get from direct flash. You should also avoid red eye completely with bounce flash.

Because the F36AM tilts only up, you can't bounce off the ceiling if you turn the camera to a vertical orientation. You can bounce it off a wall if you like, or you might consider looking at the Sony HVL-F56AM, which has a flash head that can both tilt up and pivot. With a flash like the F56AM, you can bounce off a wall behind you if you like (a technique I use often).

I recommend that you shoot in your SLR's auto flash mode rather than trying to set exposure manually. Flash is hard enough to learn how to use without adding the bounce component. Your A300/A350 will take over and do a preflash before the actual exposure that you probably won't even notice. From that preflash, it'll set the proper exposure, which you can adjust later if you need to.

Another way to bounce your accessory flash is to use something like the LumiQuest ProMax System. This versatile kit allows you to offset your flash from your camera enough that you'll avoid red eye and get a much softer light on your subject. The kit comes with three different reflectors and a soft diffuser. I generally use the white reflector for indoor shooting, and the daylight-balanced reflector for outdoor flash photography.

Though bounce flash is great off the ceiling, sometimes it leaves shadows that you don't want. The LumiQuest's 80/20 frame reflects 20 percent of the light forward, offering a little more of a catch light in the eyes and a modicum of fill flash.

When among white walls, I use the LumiQuest ProMax reflector in its 80/20 mode. When used this way, the reflector's holes allow 80 percent of the light to pass through so that it can bounce off the ceiling for overall room lighting, and the rest of the reflector sends 20 percent of the light forward to fill in the shadows that are common with direct overhead bounce flash.

The combination is longer and bigger than some will appreciate, so you could also try a Sto-Fen bounce reflector. This produces a similar effect, but without as much bulk. I still prefer the LumiQuest for my own work, but a Sto-Fen is also a good choice, and it offers a wider distribution of light for wide-angle lenses. Anytime you bounce or filter a flash, however, remember that it reduces the light that reaches your target by anywhere from one to three stops, depending on what you point the flash at and what diffuser you use.

I also bounce flash off a piece of white foam-core posterboard; the same ones I use for inexpensive fill lighting when shooting portraits. I'll have someone stand off to my left or right and direct the light for me, or set the board on a chair if I'm indoors.

Multi-flash

With only the camera's pop-up flash, the Sony A300/A350 can control several other flashes at once, all aimed at the scene, all without wires. Minolta was a pioneer in wireless flash, and the Sony's Alpha line inherits this powerful flash feature. Other camera makers have developed similar systems, but the Minolta solution was the first. Coverage of this powerful feature is beyond the scope of this book, but there are several Web sites that cover its use. All you need is one or two of the current Sony flashes: the Sony HVL-56AM, the HVL-42AM, or the HVL-36AM, and the Alpha's flash can control them. From the Function menu, select Flash Mode and scroll down to WL (Wireless).

You can do quite a lot with just one remote unit by employing a white card as fill. With one flash off to the left or overhead, you can light the subject, then let the white card fill in from the front.

OUTDOORS
THE GOLDEN HOUR

The secret to photographs that raise eyebrows is to take them when people seldom do.

Catching a good sunset shot is really quite difficult, because houses, power lines, and other unappealing objects are usually in the way when we notice that a lovely sunset is in progress. But if you can't capture a great sunset, you can take advantage of the unique golden light that the sunset gives you.

This shot takes advantage of the low sun and its golden light against the fresh spring grass.

The golden light plus its long shadows can make interesting shots. Keeping the background simple and the shadows clean is the challenge. Two out of four of these shots had my other kids' shadows messing up the simplicity.

Varying by geography, hemisphere, weather, and season, a sunrise or sunset can take a long time or happen quite suddenly. In general, that golden light is available for about forty-five minutes, so you have to work fast. Forty-five minutes really isn't a long time if you have any setup to do; and if you've noticed the sunrise or sunset at the last minute, you have even less time to work.

Probably the best time to get truly unique photos is at sunrise, because few folks are out, and the air is often different at that time, perhaps because there's less smog from the day, and the dew is often rising. Much as using on-camera flash is bad because nobody sees that way, taking pictures at this time is good because it is a beautiful, unique form of light that holds the promise of a new day.

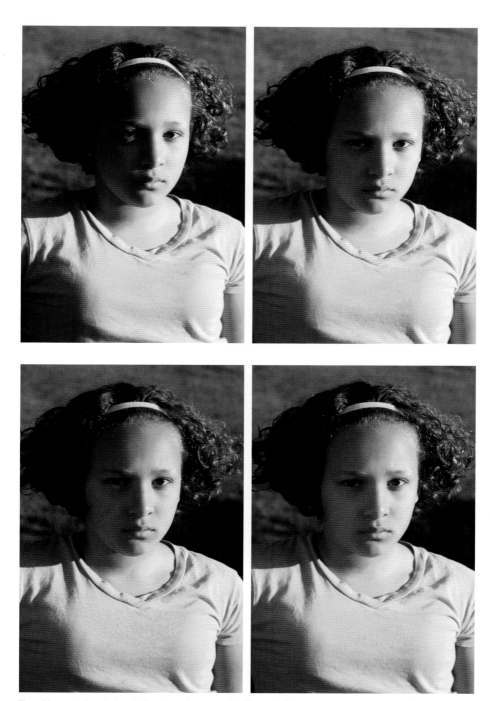

The white posterboard at work. Here's another example of how the $4 white reflector can improve your outdoor shots. The first shot has no white card; then it's at four feet, three feet, and two feet. At about two feet, it becomes so bright that it's difficult for the model not to squint; hence the determined expression in these images.

BACKLIGHT

Light coming from behind can create an underexposed photo if you're not careful, and lens flare can get you, too; but if you plan it, backlighting can create some dramatic effects. Whether indoors or out, you can use backlighting to cast your subject in silhouette or light up their hair with a halo of sunlight. It's all about where you choose to meter from.

Backlighting can be complicated, but with a little fill flash, anything's possible. This was taken with an accessory flash for fill, with the LumiQuest ProMax and the gold reflector to balance with the sunlight. The light all around was so green from the grass that I had to add a magenta filter in Photoshop to bring it back to a more normal appearance.

For silhouette, meter off the bright background, preferably in Spot Metering mode. If you want the background to be brighter or dimmer, you can adjust the EV setting accordingly. If you're shooting outdoors, especially when shooting toward the sun, you can meter off the sky next to the sun. (Be sure not to look directly at the sun, even through your viewfinder.) Then recompose and make your shot. Because it's digital, you can just keep checking until you get the effect you want.

If you want to light a person's hair, however, meter off their face. You might have to use Spot Metering mode again, depending on how close you are to your subject.

Shooting into the sun can ruin your pictures if you're not careful. Light has flooded the optic and bounced around so much that it's destroyed all contrast. Adding a lens hood on a longer lens and changing the angle a bit helped get the shot.

You might have to watch for lens flare in either case, if the sunlight is streaming into the lens—you can use it for dramatic effect as well. You can shield the lens from some lens flare with a large hood or even use your hand. Sometimes it's also easier to use your subject to shield the lens from the sun, creating a dramatic halo around your subject. Finally, you can fill in with a white card or professional reflector.

Overcast sky

Most people don't enjoy an overcast day. But an overcast sky is a great time to take pictures, because the light is coming from everywhere, falling on everyone and everything quite softly. The entire sky is like a softbox (a soft box is a photographic tool that sheds very soft light on a subject, much like light from a big window). Shadows in this light are soft-edged, so you have a wider range of shade that you can use if it's too bright under the open sky. It's a great time to put your subjects under a porch, or against an interesting building, because the light will find them, wrap around and caress their features, and make them look beautiful.

Night photography

Opportunities are myriad after nightfall. Bring your camera, your tripod, and a warm jacket, and spend a little time searching for something interesting. Car headlights are always fun ways to paint with light at night. Use small apertures and long exposures. But try different apertures as well, as you'll usually have time to experiment. Use a remote release to prevent camera shake, or just set the camera to its two-second Self-Timer mode.

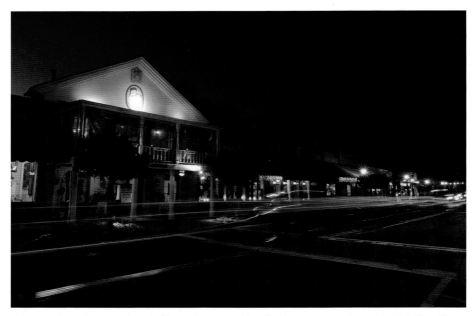

There's nothing as fun as getting out after sundown and taking a few long exposures. You need a tripod for a three-second exposure like this, and the cars need to be moving. This was about an hour after sundown, which produced the wonderful blue glow in the sky.

A quick switch to Night Shot mode captured in one image the toy that was more popular than the rides. Exposure: f/5.6, 1/10 second, ISO 400.

And with people pictures, don't forget your Night Shot mode. It's invaluable for maintaining ambient light while capturing your subjects with the flash.

Shade

Shooting in the shade is the best way to deal with a bright sunny day, unless you have elaborate lighting equipment to fill in shadows. Find the shade of a building in the afternoon, preferably with light falling on nearby buildings, and you'll have light to spare, as the whole world and the sky light up your subject. Set the white balance to Shade, and you should be all set in most situations. Make sure that buildings reflecting your light don't have a strong color of their own.

At only 1:30 pm, the sun had cast a good shadow over this building. Though the light was cold, setting the white balance to Shade helped warm it up, and a pop from the flash put a sparkle in the subject's eyes.

The Lenses

Introduction
Conversion Factor
Choosing a Lens
Wide-angle Lenses
Standard Lenses
Telephoto Lenses
Close-up Lenses

Introduction

The greatest benefit of an SLR is the ability to change the lens. Attaching a different lens transforms the camera's vision of the world—and that can transform your vision of the world. Because there are so many lenses to choose from—made by Minolta, Sony, and third parties—complete coverage of each lens is out of the scope of this book, but I'll go over the basic lens types, and what each does to enhance your vision.

It was hard to ignore how the clouds were mocking the orange trails from the nearby geysers in Yellowstone National Park. The only way to capture it was with a very wide-angle lens. Exposure: f/13, 1/400 second, ISO 100.

Conversion Factor

First we should discuss Conversion Factor, also called Crop Factor and Focal Length Multiplier (FLM), and what it means. The sensor in the Sony A300/A350 is smaller than that of a 35 mm camera, so lenses have a different field of view than they have on a 35 mm camera. To get the equivalent, just multiply the focal length of the lens you have mounted by 1.5. The focal length of the lens is always the same, regardless of the sensor or film size, but the reason we bother with a conversion factor is partly historical, and partly thanks to the many sensor sizes on the market.

Most of us who have taken pictures with a 35 mm film camera are familiar with how our various lenses performed at that film size. A 28 mm lens, for example, was a good basic wide-angle lens for most common landscape and tight photographic situations. But attach that same lens to most modern digital SLRs, and it no longer looks so wide. The smaller sensors in the Sony A300/A350 crop the image that the lens produces, so that the lens performs like a 42 mm lens would on a 35 mm camera.

Feel free to ignore the conversion factor if you don't have the history that tells you what a 28 mm lens should look like, because the new 28 mm on most digital SLRs is 18.6 mm; and your A300/A350's kit lens is capable of zooming to 18 mm, or the equivalent of a 27 mm lens. For reference, the 18–70 mm kit lens is equivalent to a 27–105 mm lens on a 35 mm camera.

Choosing a Lens

Sony's current lens lineup includes twenty-four optics.

With twenty-four lenses currently available in the Sony Alpha lineup, making good choices is important. But what lens or lenses you choose depends heavily on what you're going to photograph on a regular basis. Sony designed the 18–70 mm kit lens to accommodate a nice range, from a good wide angle to a decent telephoto focal length, but if you want to start making more dramatic

photographs, you should consider a few different types. Unfortunately, to get to extreme wide angle and telephoto focal lengths, lens manufacturers have to be more precise and use more expensive materials. You can spend anywhere from a few hundred dollars to several thousand to get the exact lens you want.

You can research lenses on many Web sites, and you can even go into many stores to try lenses out before you buy. But I recommend reading about other users' experiences with the lenses that you're considering. You can read reviews on Amazon.com, SLRgear.com, Photozone.de, Dpreview.com, and many other photography forums. See the Links chapter for more suggestions.

ZOOM OR PRIME?

When most folks start to think about a new lens, it's a question of which zoom lens they're going to purchase. Most don't even know what a prime

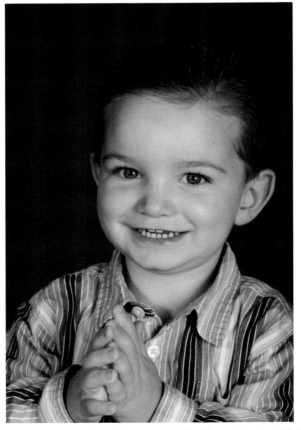

The magic of a prime lens is clear in this shot, which was made with a 60 mm prime lens. Note how quickly areas out of the plane of focus fall into softness, with the sharpest part of the image being the child's eyes. Exposure: f/6.3, 1/250 second, ISO 100.

lens is anymore. In the interest of improving your photography, I'll introduce you to the "prime lens," also known as the "single-focal-length lens."

When I was younger, primes were all I had: a 35 mm, a 50 mm, and a 135 mm lens. To "zoom," I had to either change lenses very quickly, or move closer or farther away from my subject. When I finally graduated to zoom lenses, I thought I was set. But suddenly the quality of my pictures declined, and the beautiful portraits I consistently captured were busy and less interesting. Even my composition suffered. I eventually figured out that I was too in love with zooming—I was missing those primes.

This fast little 50 mm f/1.4 is a good place to start exploring primes. This much light-gathering capability will also help you get beautiful shots indoors.

Primes are usually faster, meaning that they have wider maximum apertures so that they can gather more light. Those wider apertures mean that in-focus subjects can be set apart from the background easier, making simple snapshots into lovely portraits. Having to change lenses made me work more for the shot than I did with zoom lenses. I had to think rather than zoom. Sometimes that meant cropping creatively; sometimes it meant running to and fro. It always meant doing what I could with what I had on the camera, or committing to a lens change. My timing was razor-sharp, and my sense of anticipation became like mind reading.

You can build those senses with a zoom, too, but unless you shoot a lot, zooms can make you lazy. If you truly want to hone your photographic skills, invest in a prime or two. They're worth it for what they'll do for your photography.

Wide-angle Lenses

Wide-angle lenses give you the flavor of a place. I can remember the sounds and smells of this place with this one image, taken at about 11mm. Exposure: f/8, 1/200 second, ISO 100.

Wide-angle lenses give you a view of your world that's similar to the view you see when you turn your head. It's wider than a human's normal field of view, and is great for capturing scenic views and also for getting a unique perspective on groups, parties, and friends.

Wide-angle lenses often distort straight lines and change perspective on both near and far objects. Objects further away will seem smaller than you see with your eyes, and those close can change shape, thanks to that distortion.

Sony 11–18 mm, f/4.5–5.6 DT.

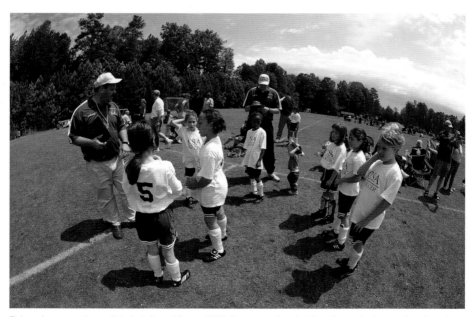

Fisheye lenses capture a distorted view of the world. Their uses are few, but they do create drama where there is little. Exposure: f/8, 1/500 second, ISO 200.

Shorter focal lengths increase the effect; hence an 11 mm lens produces more perspective distortion than a 16 mm lens, and of course it captures more of a scene.

Depth of field increases as well, meaning that objects near and far are easier to keep in focus at more aperture settings than you'd find with standard or telephoto lenses (described in following sections).

Another magical quality that very wide-angle lenses have is that they can turn a normally mundane scene into an interesting story. Dirt, rocks, and cigarette butts on the ground can become major players in a scene that also includes the most beautiful subject, because they're often as sharply focused as the subject.

Fisheye lenses will give you a very distorted perspective, creating quite a bit of drama in an image; they're fun, too.

To keep horizon lines from bending with many wide-angle lenses, keep the horizon line at the center.

Buildings will appear severely tapered at the top, creating a sense of dramatic height. Exposure: f/3.5, 1/30 second, ISO 3200.

Standard Lenses

With the advent of digital photography, the definition of a standard lens has changed, and now depends on the type of SLR you have. Indeed, it has never been a single focal length, because it varies by film or sensor size. On 8 × 10-inch film cameras, for example, the standard lens is 300 mm. Again, that conversion factor issue raises its head. To get a lens with a "standard" or "normal" view, you take the diagonal measure of the sensor. For the Sony A300/A350, that's roughly 28 mm, so a 28–35 mm lens would equate to the definition of a standard lens. To exactly match a 50 mm on a 35 mm camera on your camera, you need a 33.3 mm lens. Though the 50 mm is generally accepted as the true standard for 35 mm cameras, by definition the standard lens should be a 43 mm lens, because the diagonal measure of a 35 mm frame is 43.3 mm.

The other factor when determining the standard lens for your particular camera is whether the perceived depth is distorted at that focal length. Many 28 and 35 mm lenses designed for 35 mm cameras distort depth regardless of their crop factor, so it's hard to get a perfect match.

Today when one says "standard lens," most of us think of standard zoom lenses. These zoom around the same range that the 18–70 mm kit lens does. Sometimes the overall zoom range is shorter; sometimes it's longer, like the Sony 16–105 mm, which still revolves around that middle range.

A 35 mm lens zoom is a good lens to roughly match the angle of view of a 50 mm lens on a 35 mm camera.

Standard lenses are good for capturing what you're used to seeing with your eyes, plus your mind's eye. Humans don't see in snapshots—we see over time, and we also see based on our concentration level. So a standard zoom takes you from a moderately wide angle—what you see when you turn your head, and through a wide-angle lens—to a moderate telephoto range: what you see when you focus your general attention on something.

The main reason to consider a standard lens is to improve the quality of your kit lens. You'll want a wider aperture, and sometimes a greater focal length range.

A standard prime lens is a good choice as a first prime. I'd recommend anything from a 28 mm to a 50 mm lens, though the 50 mm is bordering on a mild telephoto lens (and is great for portraits). Beware, however, that on the 28 mm lens especially, that tendency to make far objects appear more distant remains, despite the crop to a field of view equivalent to a 42 mm lens on a 35 mm camera. That distortion can also affect faces, lengthening noses and enlarging eyebrows, so avoid a 28 mm lens for portraits.

Standard zooms see how your mind's eye does, and are great for general-purpose photography. At 65 mm, a great portrait can be taken from just a few feet away. Exposure: f/5.6, 1/160 second, ISO 400.

Telephoto Lenses

The advent of the cropped sensor did more for the telephoto side of the equation than any other category. The old standard 70–200 mm lens now has the effective range of a 105–300 mm lens. That makes a real difference when it comes to isolating your subject in the frame, which is exactly what we do when we concentrate on a subject: our mind zooms in on it. That sounds strange, but new

A telephoto lens is important to get in close and tight, and it often makes isolating your subject from a busy background that much easier, thanks to the background blur, or "bokeh." This telephoto zoom was set to the equivalent of a 248 mm lens. Exposure: f/4.5, 1/250 second, ISO 100.

photographers are often frustrated by their camera's inability to reach into a scene and isolate a subject like their mind can.

As they get longer, telephoto lenses begin to compress depth, flattening facial features and bringing far objects closer—quite the opposite of how a wide-angle lens makes objects seem further off than they are.

Though depth is compressed, depth of field also shrinks, so accurate focus becomes more important. With a particularly wide aperture, depth of field can be so shallow that eyebrows are out of focus while eyes are sharp. The closer you get to your subject, the more this effect is exaggerated, so watch your apertures and zoom in to check that the areas you want in focus indeed are.

Shot at 184 mm, this portrait mainly has the eye in focus, and all you can tell about the background is that it's green.

Good portrait lenses for the Sony A300 and A350 start at about 50 mm and go up to 135 mm. The old extreme was 200 mm for portraits, but the 135 mm is equivalent to a 202.5 mm lens, so 135 mm is as far as you need to go for a good portrait lens on your camera.

Primes are especially good in this range as well, and you can usually get a good telephoto prime with a wide aperture for less money—and less weight—than you can get a good telephoto zoom with a wide aperture.

For field sports, you'll want at least a 70–200 mm lens. If they're all daylight shots, an f/4 or f/4.5 lens should do fine; but if you're shooting night field games, you'll want to invest in something with a larger maximum aperture, like the Sony 70–200 mm f/2.8 G. It's expensive, at just under $2,000, and weighs three pounds, but it'll get the job done in more places, so it's a good investment if indoor and night sports are important to you.

Close-up Lenses

There's one more perspective that the mind's eye can see that you can capture with a lens: the close-up. Although our ability to see small objects up close can degrade significantly as we age, when we were kids, many of us could look very closely at ants and other small objects and study them in detail. You can return to those days with a good close-up or macro lens, capturing minute detail and making mundane objects into fascinating works of art.

Sony makes two lenses that serve this need: the 100 mm f/2.8 macro and the 50 mm f/2.8 macro. Both are capable of 1:1 reproduction, meaning that the object of your focus will appear life-size on your sensor.

The dramatically decreased depth of field with close-up lenses is quite clear in this photo of a U.S. dime.

Plants, insects, coins, and even electronics can take on a new life through macro photography.

Depth of field decreases yet again in macro mode, so you have to be careful. At extreme macro levels, depth of field is so shallow that serious macro photographers will often take several images taken at different focus settings and combine them to achieve sharp focus across an object.

The Subjects

Portraits and People
Kids and Pets
Travel
Action

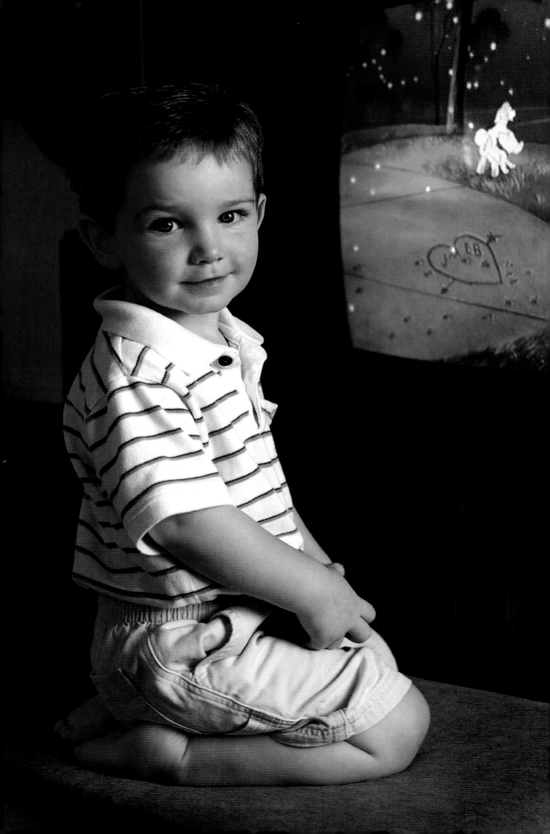

Portraits and People

People are my favorite photographic subjects. I'm not alone—most of us take pictures to capture memories of friends and family as they grow, and as we participate in and explore the world around us. Human faces and bodies are endlessly interesting, capable of conveying emotion even at complete rest. Until we get a camera that challenges us, most people just take smiley snapshots of their friends and family. Once you start to grow as a photographer, however, you begin to see how the combination of light and pose can convey personality, even among people you don't know. As you're just sitting, talking to a friend, or watching someone do something completely ordinary, it will strike you: that's a beautiful portrait. If you have your camera nearby, and know how to use it just right, you can capture that person in a flattering light.

Portraits attempt to capture something about the person to portray them as they are. Portrayals can be simple or elaborate. A basic portrait features the person's face and little or no background detail.

Portraits needn't be focused on a face, however. Spending time with people in their environments can tell you a bit about what they like to do. Sometimes if you step back, you'll see that their surroundings have a lot to do with who they are. You might also find that they're more relaxed on their own turf.

I caught this shot of my son watching his favorite movie because I was ready. I saw that the light was just right and asked him to look over at me.

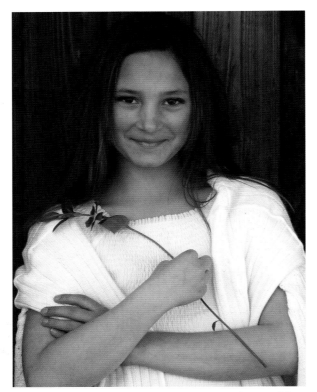

A portrait captures an inner light. Sometimes a prop can take the subject into that zone. A flower can make a female subject feel pretty; and when they feel pretty, it shines from within. This shot, taken on the street in an old cove between buildings, only about two feet deep, provides a very flattering, soft, natural light.

LENS SELECTION

There is no perfect lens for portraiture, though photographers often have their favorites. A mid-range zoom like the 18–70 mm will do if that's what you have, but if you want to explore the art of portraiture, consider a wider-aperture zoom, like an f/2.8 zoom that zooms in to at least 80mm. A wider aperture lens lets you blur the background, isolating the subject as the only clear object in the frame. Better, though, is a prime lens, something like a 50, 85, or 100mm lens, available with large apertures of f/1.4 to 2.8. These will be equivalent to a 75, 127, or 150mm lens, which will let you keep a comfortable distance from your subject so that they relax. After a few shots, when the model is more comfortable, you can move in for the cover shot, or stand off with that 100 or 135mm lens for a flatter perspective, throwing the background out of focus.

HOW TO SHOOT

First, go to the local art or office store. Buy yourself at least two white foam-core posterboards. You'll use these as fill light.

Finding an old town is usually a gold mine for interesting portraits. I enjoyed how my youthful subject looked against the old, rustic background. She brought a nice prop, the hat which we used only a little at the beginning to break the ice; in our better shots there was no prop. Exposure: f/4, 1/60, ISO 100.

Next, find good light; preferably outdoors, in the shade, but where there's still a lot of light bouncing around. (If you can't find that combination, remember the foam-core boards.) For interest, one thing you can do is take your subject to an old town with some character. Follow these steps:

- Set your meter to spot and take a reading off your subject's cheek, or even the inside of your hand, facing the same angle as the subject's face to match the light.
- Choose Aperture priority mode, set the ISO to 100, and make sure that everything else is set to defaults.
- If you have a zoom, zoom out, then in. Consider the scene.
- Stop and look your subject in the eye. Ask them, "Are you ready?" If not, ask why, and what you can do to make them more comfortable. An uncomfortable subject makes a terrible picture.
- Once your subject is settled and ready, say, "Okay, I'm just going to take a few test shots," and do just that.
- Focus on the eyes. Don't shoot with a wide-open aperture until you're more comfortable with using your AF points. When you think you have it, open up all the way.

Once you have an interesting pose in good light and some character, explore the possibilities with your subject. Here's a totally different expression from a slightly different angle. Exposure: f/2.5, 1/160, ISO 100.

Look at the histogram. Confirm that all your piles are not bunching up too far right or too far left. If you don't have it, try a different aperture or ISO setting to get it right. Try to keep the aperture wide, unless you've decided that you want to include the background.

If your subject is in shadow, try the white foam-core boards. Move one into the light and move it around a bit; see what it does to the subject's face. If the person is squinting, don't leave the board there. Talk to him or her, saying what you're doing—and if it turns out that the board is too bright, forget it. Try a different pose. If something's not working, move on.

Move around a lot. Take a few shots, explore it, ask your subject to look hither and thither to get a different look, then have them look back at the camera. It usually doesn't take long for you to get synchronized. Often your subject will start thinking of his or her own ideas for poses, looks, and places to use as backgrounds.

As you move, you'll find all kinds of different opportunities. Try everything. Try new metering modes, try the same shot with a wide aperture and with a tight one. The feedback is instantaneous on the back of your Sony Alpha, as well as on the face of your subject, so experiment and have fun.

My subject surprised me with her confident and artistic poses. After a few shots, we wandered to an old courthouse, which offered a more modern backdrop of rough rock that again juxtaposed nicely with her soft skin. The large rocky structure scattered the light such that I really didn't need the reflectors often, and the large architecture channeled the wind just right so that I didn't need a fan to blow her hair.

Kids and Pets

Kids and pets are the most difficult and rewarding subjects to shoot. There's such innocence, such mischief, such joy, and such sadness: they're a microcosm of all we are, and the opportunity to juxtapose the extremes of adult emotion with childhood play can be infectious.

Change it up. When photographing kids, take advantage of the angles. Rather than getting down to their level (a good tip, nonetheless), or shooting from the common adult angle, I went up on the deck and caught these guys by surprise, and the perspective on their wild sandbox fun was captured all in one shot.

151

LENS SELECTION

You need a mid-range zoom for this type of subject. As with anything, the sharper, the better—but the 18–70mm kit lens should be fine. If you can afford a large-aperture lens for indoor shots, that's even better. If you're already used to shooting kids with a zoom and want to punch it up, go for a mid-range prime, like a 50mm lens. It'll make you work, but the results will be worth it.

Shooting kids with a prime lens can be a challenge, but the rewards are often great. Exposure: f/4, 1/60 second, ISO 400, pop-up flash.

HOW TO SHOOT

I have a few basic tips that can make getting a good shot easy.

First, be prepared to take a lot of pictures, and be prepared to throw most of them away. Even the fastest autofocus system and the best camera are challenged to keep up with a rambunctious child or curious pet. So it's only through practice that you can learn to anticipate a child's actions and at the same time know how your camera will respond when presented

with each new challenge. If you come away from your first try with one shot you can hang on the wall, you're way ahead.

Second, move your subject to somewhere with some light. Find a big room with white walls and light-colored carpet, and with a big window. If light's streaming straight in, reflecting off the light-colored carpet, either shoot from the opposite wall or pick another room. I like indirect light streaming in that window, if possible. If soft window light is not available, move outdoors into shade. Bottom line: get your camera some light to work with so that you can set an exposure of at least 1/60 second at ISO 400, and preferably 1/125 second or higher to freeze their motion.

Third, get down to their level. Occasionally shots from the average adult height can tell a story, but we've all seen kids and pets from that height. Find out what they look like from their own height. Or get lower than they are and shoot up. Here's where the Sony A300 and A350's tilting LCD can come in handy. Whatever you do, change the perspective and you'll find that you learn a thing or two about your subject, *and* get an interesting photograph. You'll also find that your subject responds to you differently when you change your usual level of interaction.

Fourth, work with them until they get tired. Give them a rest. Have a snack, let the sun go down a bit. Then start fresh. This is when the good photos can start happening. They're familiar with the process; you're familiar with them. Some of my best shots have come at these times. (This is also a great tip for the portrait topic.)

Fifth, if they're your own kids or pets, be ready all the time. I keep at least one camera out of its bag, charged, loaded, and ready to shoot at all times. No "if I only had a camera" lamentations from this guy. I am ready all the time, with an SLR at home and a pocket camera when I'm out at an event where an SLR would be too much—which is rare.

Travel

Lens selection is obviously important when traveling with an SLR, because you want to cover as wide a range of subjects as you can, but bring as little equipment as possible. Depending on whether you're traveling to enjoy, or traveling to get great photos, the size of your kit will vary. People agonize over what to bring on a trip, and packing an SLR is no exception.

Having the right lens on a trip is essential, but this was taken with a standard 3x zoom. It helps to have beautiful surroundings like Lake Tahoe, but I did have to wait until everyone left this one small section of beach.

LENS SELECTION

Many SLR owners will opt for what many call a "vacation lens." These usually cover from 18–250 mm and fit into a small space. However, to get such a long zoom range, manufacturers usually have to sacrifice quality, and those sacrifices often come at the extreme ends: wide angle and telephoto. This issue makes me wonder why anyone would want to bring the lens at all. There are a few good ones out there, but I recommend a two-lens approach for better quality.

Many unusual sights await you as you visit other places, so make sure to get interesting shots while you're there. I held the camera over my head to get this nice shot of a busy shopping area in Japan.

Bring a wide zoom like the DT 11–18 mm f/4.5–5.6 Super Wide Zoom Lens if scenes and landscapes are your main interest. An extreme wide-angle lens also allows you to capture a greater scope of where you've visited, more like your mind's eye sees a place as you turn your head. All the small details that may look like trash or just uninteresting detail take on a new look in a super wide-angle lens. Cathedrals of course look stunning, train stations look as vast as they are, and you can even put some of your travel mates in the shot for a personal touch.

Bring a longer telephoto. If weight is an issue, the Sony 55–200 mm f/4–5.6 Telephoto Zoom covers this end of the focal spectrum quite well. If weight and money are not issues, the 70–300 mm f/4.5–5.6 Telephoto Zoom provides all you need in a slightly larger package.

When traveling locally or abroad, be sure to get a shot of your entourage. A shot of everyone sitting in the bleachers would be a snapshot. By waiting until folks left, I was able to go up into the bleachers and get this telephoto shot that included the group and a nice backdrop of the baseball stadium, telling the whole story in one shot.

If you must have only one lens, consider the more conservative DT 16–105 mm f/3.5–5.6 Wide-Range Zoom Lens. Covering the range equivalent to a 24–157 mm lens, the 16–105 mm is an ideal companion, capturing just what you need, from full buildings and interiors to reasonable close-ups across a room or small courtyard. As a one-lens solution, this is what I would choose. And I would also bring along a nice prime lens for occasional portraits or flower shots, like the Sony 50mm f/1.4 lens. (Wait, did I say "one-lens solution"? Hey, it's an SLR—you have to have another lens! You might never visit this place again, right?)

HOW TO SHOOT

This is a subject for an entire book. But I can sum it up in four words: shoot all the time. You have a nice, capable little SLR that can work wonders. You're on vacation in a new place, so everything looks interesting. Your companions are more relaxed than you ever see them at home, so make sure that you take a picture!

All I can do is tell you what I do when I'm out traveling. I see photographs everywhere. Stories in every face, wonder in all facets of a building.

Naturally I can't capture everything, but I try to get the interesting stuff. I'm usually also reviewing a camera, so I spend time trying to learn about the camera. You can do the same. See what your Sony A300/A350 can do. Push it. But don't forget to relax and have a good time. After all, if you don't get the shot just right the first time, you'll have a great excuse to come back.

I made this rather unusual self-portrait/silhouette while suffering jet lag in Tokyo. I'd been trying to get a few night shots out my hotel window, but was frustrated by the reflections from the room. So instead of getting frustrated, I doused the lights and used the screen from a handheld computer to trace my silhouette in the window's reflection. Weird, but interesting. Exposure: f/10, 30 seconds, ISO 100.

Plan to get up early one morning to take a walk and shoot the sunrise. Bring something to sit on and something to eat. Make it a sunrise picnic. Be out and about at sunset. And don't let darkness stop you. Restaurants and shops work hard to make their venues look enticing; usually with creative lighting and interesting architecture. Hike to the top of a hill and take a few night shots. Or even just look out your hotel window at night, prop the camera someplace firm (if you didn't bring your tripod), and take a few. If there's no way to open the window, turn off the lights in the room and shoot at an angle to avoid reflections. If you're not sure where to go for good photo opportunities, ask the concierge, a waiter, or some locals where they recommend.

Whether you're on a casual vacation or a business trip, there's no reason not to capture it with some flair.

Image stabilization and high ISO can work wonders when shooting at night, especially at fireworks shows. This was taken handheld at f/4, 1/50 second, ISO 1600.

Action

Capturing action is easy, but the biggest problem for most people is getting close enough to the action in difficult lighting situations. You can invest in a telephoto lens, but even that will seldom get you as close as you'd like from the bleachers, and the light is significantly choked off for anything but sports played in broad daylight.

That's why you see all those big fat lenses down on the sidelines. They're so close to the action that I'm sure people wonder why they need such large lenses. But they're large in order to gather more light, not necessarily to magnify the scene. They're shooting with 200mm and 300mm lenses on the sidelines of most games, because the extra light lets them shoot at higher shutter speeds. You'll see these big, fast lenses at indoor wrestling matches and basketball games as well for the same reason: gathering more light.

But as most of us can't afford these $2,000-plus lenses, we have to innovate and know our limitations.

LENS SELECTION

If action is your subject of choice, you'll want a lens that's faster than your kit lens, as well as a telephoto lens that's faster than the inexpensive one that comes with the larger kit. Unfortunately, if you're going to buy Sony-brand lenses, you'll find that faster lenses are all more than $1,000. If you can afford a fast prime like the Carl Zeiss Sonnar T* 135mm f/1.8 Telephoto Lens for $1,399, or the Sony 70–200 mm f/2.8 G-Series Telephoto Zoom Lens for $1,999, those are great choices for beginning to advanced amateur action shooting.

If that's not in your budget, my recommendation is to buy a flash to help light your subject, and work on getting down on the sidelines, because you gather more light by being closer to your subject; and your flash will work better too. Or shoot in daylight. So many parents want to get a camera to take pictures of their child's sporting events, but are disappointed that night and indoor shots never look good. Expect that, and you won't be disappointed. They won't look good in most cases, which is why pros spend so much on their gear. You'll have to get close, and shoot a lot.

HOW TO SHOOT

This is also a book-length topic, but the basic instructions are to go for the extremes: shoot with a fast shutter speed and a wide aperture to freeze action and blur the background, or shoot with a slow shutter speed and follow your subject while you shoot, so that the background blurs and the subject is sharp. Set the camera to continuous mode, set AF to Continuous tracking, and keep on shooting with a big card.

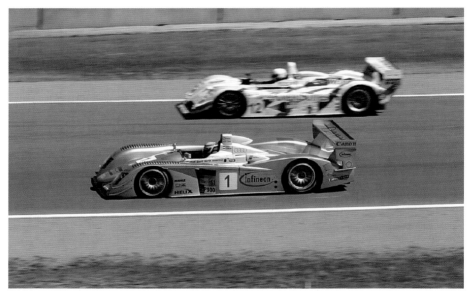

The silver car was going fast enough that even at f/9 and 1/400 second, I was able to pan after the faster moving car and both the other car and the background blurred from the motion.

Even when shooting action in the daytime, you might want to raise the ISO to 400 so that your shutter speeds can get faster—in the 1/500 second or greater range. Just make sure that your highlights aren't blowing out.

If it's a very bright sunny day, don't forget to mount the flash and set it to HSS mode (see Flash under the Accessories section). You can fill in the shadows in your action shots if you're close enough to the action.

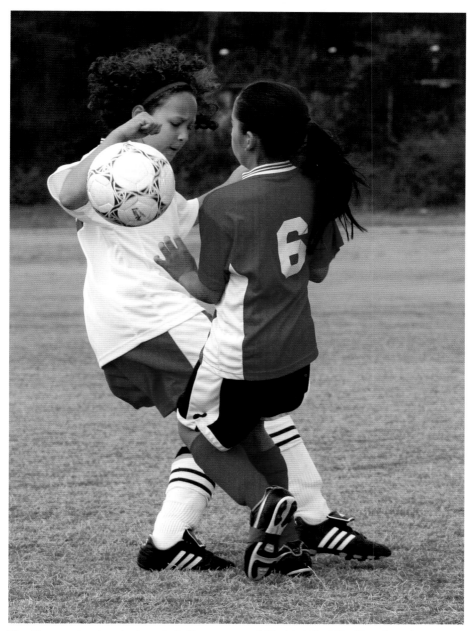

When it's overcast, you're going to need a fast lens, or you can fall back to higher ISO settings. Soccer is particularly difficult, thanks to relatively random fast action, so on this day I chose f/8 at 1/1000 second, which required an ISO setting of 800.

Part 6

Accessories

Introduction; Flash;
Tripods; Remote Controller;
Battery Grip; Printer

Introduction

In addition to better image quality and interchangeable lenses, the SLR has a further benefit over the point-and-shoot camera: accessories that extend its capabilities to better meet your specific needs. You can add flashes, a vertical grip, remote control units, adapter cables, and even dioptric lenses to make the Sony A300 or A350 work just right for you. Naturally, you don't have to add any of these items to get good pictures, but quite a few enhancements do make getting great shots much easier.

Don't make the mistake of buying a lot of stuff that you don't need. Build slowly and make sure to purchase items that you'll actually bring with you and use often. If your camera kit is too big, it might not go as many places as you envision. An over-stuffed camera bag looks cool, but it's heavy, vulnerable, and raises the price of each picture significantly.

The type of photography that you intend to explore helps determine what you put on your short list of desired accessories. Some photographers couldn't do without a tripod; others start to cramp up at the very thought of a tripod. For landscape and long-exposure work, a tripod is essential, but not for portrait work. I'll go over a few essential items first, then the optional ones.

Flash

The most versatile and useful accessory for an SLR is an external flash. If your common shooting opportunities include a lot of indoor photography of people, a flash will make you much happier with your images. Shooting without a flash is usually preferable for a natural-looking picture, but not always possible. With Sony's modern strobes, you can work wonders.

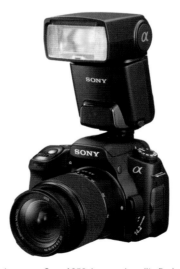

The Sony HVL-F42AM, shown here on a Sony A350, is a good quality flash unit with an internal zoom mechanism and a multi-directional bounce head.

Again, consider all accessory purchases carefully. Buying and bringing a flash is a commitment. They're big, heavy, and make your camera more of a burden to carry. If you've also brought a large or long lens, the combination can get uncomfortable. But I can tell you from experience: if you're committed to using a telephoto zoom, you should also commit to the flash. A flash is more likely to get the shot you want, because you seldom have enough light for telephoto lenses. That's true indoors or out.

CONVENTIONAL STROBES

As of this writing, your choices in Sony flash units are the HVL-F36AM, HVL-F42AM, and HVL-F56AM. The three units are in ascending order in terms of power and price, and each unit is labeled with its "guide number." A guide number is a standard used to compare relative power of a flash, and is generally stated in meters. So the F36AM has a guide number of 36 meters or 118 feet, the F42AM's guide number is 42 meters or 138 feet, and the F56AM is 56 meters or 184 feet.

The Sony HVL-F56AM has greater range, yet has the same bounce and zoom functions as the F42, including AF assist in low light—an invaluable tool at night and indoors.

All three of these flashes allow you some form of bounce flash capability, meaning that you can tilt the head up to bounce light off a ceiling, wall, or other reflector, which makes for a more natural appearance. The F36

swivels only up 90 degrees, but does not swivel left and right, so I recommend looking at the F42 or F56, whose flash heads swivel up 90 degrees, left 90 degrees, and right 180 degrees (actually, the F56 reverses the order, swiveling 180 degrees left and 90 degrees right, but the effect is the same). The F56's flash head also tilts 10 degrees down to help illuminate close-up subjects.

All three flashes use ADI (Advanced Distance Integration) technology to properly gauge subject distance based on the lens's focus position. And all three also offer high-speed sync, up to the limit of the A300/A350's 1/4,000-second shutter speed. This mode comes in handy when you want to use fill flash outdoors while also using a wide aperture to blur the background in portraits.

Each flash has a few more abilities, but probably the most important ability is the focus assist beam that comes from behind the clear red plastic at the front of the flash. You can usually see its pattern in the flash briefly on the subject as focus is being set. This tool makes autofocus in low light significantly more effective, and is one more reason to consider an external flash unit for your Sony Alpha digital SLR.

GUIDE NUMBER AND ADI

Be aware that the guide number doesn't mean that the flash reaches those distances at every aperture. In fact, it fully illuminates a subject at that distance only at f/1.0. Because the kit lens that comes with the A300/A350 has an aperture of f/3.5, the maximum distance that Sony's most powerful flash—with a guide number of 56 meters (184 feet)—properly illuminates is 16 meters (52.5 feet) at ISO 100. Zoom that lens in, and the maximum aperture changes to f/5.6, and the maximum range is reduced to 10 meters (32.8 feet).

The formula used to calculate the guide number is: GN = distance × f-number. To get the numbers provided in the previous paragraph, I took the guide number and divided it by the f-number to determine the maximum distance (distance = GN/f-number).

To determine what aperture you want to set your camera to when using the full-power flash, just flip things around and divide the guide number by the distance (f-number = GN/distance). For example, if my subject is 20 feet away, and I'm using the F56AM, I calculate 184/20 = 9.2. Because there is usually no f/9.2, you can safely set f/9.

If you're a big math fan, and good at calculating in your head, set these sophisticated flashes to Manual and go for it. But as I'm the writer/artist type, I'm thankful that the Sony Alpha line has ADI and Pre-flash TTL metering built in, which means that the flash makes these calculations for me when I half-press the shutter button. Life's too short for calculations while you're trying to be creative and get a good photograph.

To make those calculations, your camera bases the flash exposure on the subject's distance, as revealed by the lens's focus setting when used with

a Sony, Carl Zeiss Alpha, or D-Series Maxxum/Dynax lens. Excellent. It will also back that calculation up with a preflash to make sure.

The other factors that these sophisticated flashes include in their calculations make the previous formulas difficult to compute, including bounce modes, flash zoom settings, and even color temperature, so for the near term, stick to letting the flash work with the camera to set your exposures and learn about Flash Exposure compensation.

FLASH ACCESSORIES

A number of creative souls have found ways to improve the flash with simple additions to distribute the light in unique ways. Here are a few of my favorites.

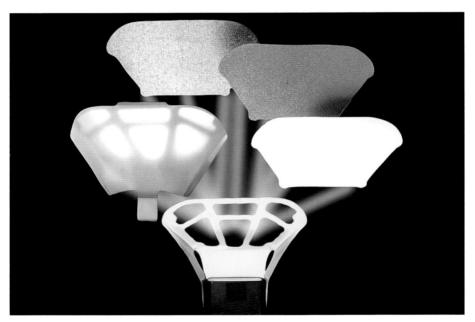

Offering three reflectors, the 80/20 frame, and a frosted diffusion screen to serve as a mini softbox, the ProMax System does a lot to improve your flash pictures, both indoors and out.

LumiQuest ProMax System In general, if my flash is on my camera, some arrangement of the ProMax System is on my flash (see illustration above). One of the main drawbacks of bouncing a flash off the ceiling is that your subjects can end up with "raccoon eyes," where the sockets of their eyes are darkened from the extreme overhead angle. I'll sometimes aim the flash backward over my head, but the ProMax's main reflector is the 80/20 portion. This unique grid lets 80 percent of the light flow through to the ceiling, and reflects 20 percent of it forward to fill in those eyes and even give them a nice "catchlight" so they appear to sparkle. In my experience, the result is spectacular.

Outdoors, I use the gold metallic reflector, which attaches to the 80/20 subframe with Velcro, to throw a little artificial sunlight into my subject's faces. It's usually more than enough to remove the blue cast that you often get from electronic flash when it blends with daylight. The combination does make my big flash bigger, but the payoff is large. The whole thing folds up into a wallet that slips next to the flash in a camera bag and retails for about $40.

Because I don't like sticking adhesive-backed Velcro on my flash, I also appreciate LumiQuest's Cinch Strap, which has rubber on one side and Velcro on the other. Just wrap it around the flash head and it'll stay in place. It's available for about $7 from www.lumiquest.com.

Sto-Fen Omni-Bounce Though it's not as elegant, many photographers wouldn't be without their Sto-Fen Omni-Bounce. Currently available only for the F36 and F56, the Sto-Fen Omni-Bounce fits over the flash head and diffuses the light from your flash all around the room. Perhaps its best feature is that it's small off and on the flash, which means that it's no burden to bring or use. The price is around $20 at www.stofen.com.

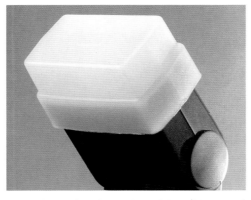

Simple and easy to bring along, the Sto-Fen Omni-Bounce throws light in all directions for a more natural look.

SPECIALTY STROBES

Two other strobes flesh out the Sony flash system, including the Macro Twin Flash Kit (HVL-MT24AM) and the Macro Ring Light (HVL-RLAM). Both are, as the names imply, for macro shooting: placing the light right next to your subject for even and precisely controlled illumination.

As of this writing, the MT24 is no longer available from Sony, but is still in stock at other retailers. This kit includes a hot-shoe-mounted flash body attached via cable to a ring that mounts on the lens and props up two small strobes tuned for close-up photography. You can move the flashes around the ring for different lighting effects. Retailing for $499, it's a pretty expensive unit, so you'd need to be very committed to macro photography to invest in a rig like this.

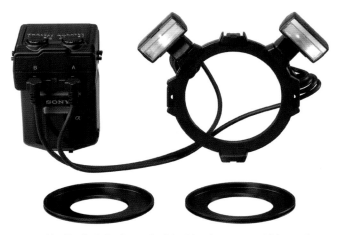

Sony's MT24 is an unusual-looking flash, but it puts the light right where you want it for good macro shots.

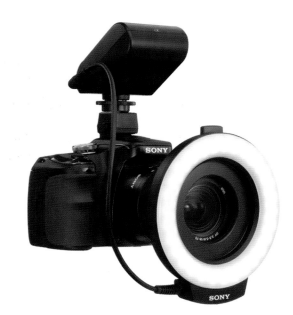

The venerable ring light lives on in Sony's flash lineup, surrounding the lens with a soft, even light.

The Sony HVL-RLAM Macro Ring Light is less expensive (www.sonystyle .com), yet still allows you control over the flash. Inside the ring are two tubes, which can be fired simultaneously or separately to create a modeling or 3D effect. It's great for putting a lot of light on extreme close-ups, where it's otherwise difficult to sidelight extremely small objects. Note that these are not the same ring lights that you'll often see in portrait shoots to create a glow over the model's entire face; those are larger, more powerful, and not available from Sony.

Tripods

Though Sony's Super SteadyShot helps in low light, if you get into the art of available light photography or want to take a group portrait that includes you, you'll need a tripod. Here's another purchase that requires commitment, because tripods are also large and cumbersome—even some of the smaller ones. To complicate matters, there is a wide range of brands and types to choose from. For your first purchase, keep it simple, aim for quality, and choose a brand name.

In the following sections, I list a few factors that you should take into consideration and make a few recommendations.

CONSIDERATIONS
WEIGHT AND CONSTRUCTION

Though everyone thinks they want the lightest tripod available, heavier tripods actually make a more stable platform. Striking a balance between your need for low weight and stability is a key challenge. Weight is also important when considering the tripod head, in terms of how much weight the tripod supports, but we'll get to that shortly.

Tripods are constructed either from very simple, inexpensive materials like aluminum, or from very expensive materials like carbon fiber or basalt. I lean toward a good quality aluminum tripod, because I don't want to spend a lot of money on something that I only use occasionally, and I doubt I'd notice the difference between aluminum and carbon fiber, except on a long hiking trip. If you live and shoot outdoors in a freezing environment, however, you'd be wise to consider the carbon fiber options, which stay warmer to the touch than aluminum.

Legs are either tubes or U-shaped construction, and they can be two-part or three-part or have up to six sections that extend from a closed position. I prefer solid tubes, but less important than tubes versus U-shaped legs is the number of sections. I recommend a three-section leg design, because more sections make for less stiffness. The whole point to a tripod is stability, and you can lose that with a five-section leg.

Joints should be tight and slightly stiff. If you hold the leg and twist, there should be no play or movement. That goes for all components of the tripod. If you go to a store and set up a tripod on a solid surface, you should be able to flick it without having it vibrate freely or rattle. It will always move a little, but you're checking for movement between the legs, base, center post, and head; resistance to vibration comes with the application of weight from the camera and perhaps a hanging weight that you add when you're on location (a full water bottle on a string serves nicely).

HEIGHT

Ideal tripod height depends a lot on your height. You want the center column to rise a little above your own height if possible, as you might be shooting on a slight slope and still want the camera at eye level. It should enable you to shoot comfortably from a standing position, or you won't use it often. Short tripods are tempting for trips, and might serve as decent travel companions in a pinch, but for local or studio work, you want the tripod to adapt to you, not vice versa.

FEET

A foot that can convert between a spike and a rubber base is ideal, but if you find a good tripod that has only rubber feet, that's not a bad compromise. Spikes are necessary in snow and helpful in dirt, but in most situations, rubber serves.

HEADS

Head choice is a whole world of its own, and varies a lot by your needs. Some prefer ball heads, others like pan heads, and still others who use large lenses opt for precision gimbal heads. For basic use with a general-purpose lens, a ball or pan head should work fine. If possible, find a head with a bubble level built in, a wide base, and a removable plate for getting the camera off the tripod quickly.

If you're looking for a tripod to use with both a still and a video camera, consider one with a pan head, which usually has a lever or two to aid in smooth panning; two levers are generally better than one. It's called a "pan" head because it can be made to hold a stable line while panning to follow a moving subject, or even to take panoramic photos.

Ball heads, on the other hand, are good for choosing from a wide range of positions quickly, then locking the position in place. If you choose a

ball head, make sure that its base is still wide, and its ball large enough to hold your camera quite securely.

Gimbal heads are more expensive designs for large lenses that are heavy enough to have their own tripod mount sockets. These are designed to balance the load evenly for easy vertical adjustment without the risk of the lens pitching forward. Expect to pay hundreds for a head like this, and be sure to put it on a large, heavy tripod. This is not an ideal backpacking design, in general—though there are always exceptions.

RECOMMENDATIONS
Manfrotto Bogen 190XDB with 804RC2 head

An excellent general-purpose tripod, the Manfrotto Bogen 190XDB (www.bogenimaging.us) is a redesign of a tripod that I've enjoyed for years: the Bogen 3001 Pro. You can find it for less than $100 without a head. The 190XDB is sturdy and meets most of the requirements outlined previously: tubular legs, stiff hinges, relatively light, stable—and this new, lighter model has quick-release leg locks rather than the screw locks on my old 3001. The legs can be opened to three positions for getting your camera lower down, or for increasing stability in windy conditions.

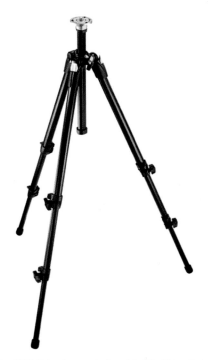

A truly excellent tripod design, the 190XDB has been redesigned, but it still has that robust character that I rely on everywhere I go.

If you want quick and easy control on a stable platform, look no further than the 804RC2.

In an effort to keep this solution close to $150 total, consider the Manfrotto Bogen 804RC2 Basic Pan Tilt Head with Quick Release, available for under $70. Made of a new composite material called Adapto, its two larger handles are easy to use, allowing you to level the camera quickly without a lot of fumbling. The combination of this head and the 190XDB tripod weighs about 5.2 pounds and retails for about $170 total.

The 190XPROB can do two tricks. The first is that its legs can be made to open fully flat, to help you get very low. The second is that its center shaft can pull up and then lay down to a 90 degree angle to serve as a copy stand or for unique macro work.

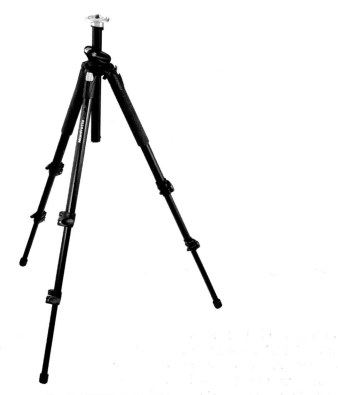

Just a little more robust in appearance than the 190XDB, the 190XPROB also has flip locks rather than screw locks.

The 190 design has many permutations, with carbon fiber and MagFibre legs; and the 190XPROB performs a cool trick, in which the center column can actually be laid down 90 degrees for extreme close-up work on the ground. This model also includes a 360-degree level on the base, and it's available for around $50 to $70 more.

This series is the best you can get in an affordable, relatively portable and multipurpose tripod with no-nonsense, professional-grade stability. You can choose from a number of standard-size heads to use with it, and enjoy its utility long into the future—I've had my 3001 for twenty years.

Manfrotto Bogen 728B Digi Compact Tripod with 3-way head

If price is an issue, and you still want the main quality components I've described, consider the Manfrotto 728B Digi Compact Tripod, which comes with a very traditional 3-way pan head with a quick release mechanism. It's a four-part tubular leg system with lever locks that stands 64.8 inches high and weighs just 3.1 pounds. It can handle a 7.7-pound load. It's available for $120, and comes with a carrying bag.

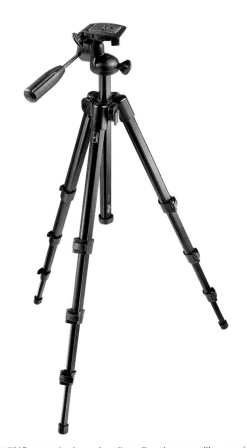

This inexpensive Manfrotto 728B serves basic needs quite well, and comes with a carrying bag.

I can't list more tripods, because there are too many. Spend around $100 or more, check them for stability when they arrive, and stick with a few top brand names: Manfrotto, Slik, and Velbon make quality tripods in the range over $100; and of course you can choose Gitzo if you want the best and have enough money.

MONOPODS

In a pinch, I've extended just one leg of my Manfrotto 3001 when I needed a monopod for shooting sports; but when I plan ahead, I bring along my trusty Manfrotto 3016 monopod. Its design is pretty straightforward: a three-section tubular aluminum construction with two quick-release levers, a spongy rubber grip, a loop strap, and a screw that will handle accessory heads or just screw into the bottom of most cameras. I tend to use mine without a head because I shoot horizontally when shooting sports, and use a second camera for portraits on the sidelines. You can spend more, but not much less for this kind of simple quality. You'll find that the model number is now 3016/679 or just 679, depending on where you look.

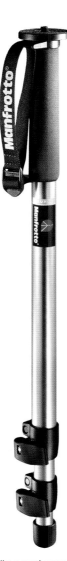

There's another kind of tripod for you to try, too. Though I usually stand for sports photography, when the players are kids half my height, it pays to get down to their level. As such, I bring along a three-legged folding stool that I also use for portrait shoots. Mine's a Shakespeare Compact Folding Stool that comes in a canvas bag that is about the same size as my tripod, and retails for between $7 and $15. REI also carries a version that they call the Trail Stool for $15, and a model with a back support that I mean to try out for $20.

There's nothing like a good monopod, and that's just what the Manfrotto 3016/679 is. Its flip locks make height adjustments fast, and the rubberized grip makes for a secure, comfortable hold.

Remote Controller

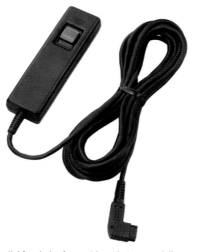

Sony's wired remote is essential for shake-free outdoor shots, especially macro and night shots.

For long exposures while your camera is on a tripod, the Sony RML1AM Remote Commander Shutter Release Cable allows you to release the shutter without touching the camera. The cable is 5 meters (16 feet), long enough to get into some pictures, if you don't mind a cable in the shot. But it's better used for vibration reduction and night photography. It features a sliding lock for bulb photography (locking the shutter open) and plugs into the side of the A300/A350.

Battery Grip

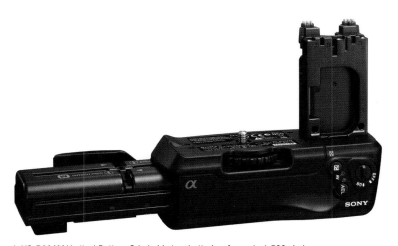

Sony's VG-B30AM Vertical Battery Grip holds two batteries, for up to 1,500 shots.

Though it's certainly not a necessity, the Sony VG-B30AM Vertical Battery Grip is a nice addition to the Sony A300/A350 for those with larger hands. It also allows for an easier hold on the camera when shooting vertically, providing a good counter-balance for long lenses. It includes a secondary shutter release, Command dial, EV/AV adjustment button, and an AE Lock button, duplicating the controls on the camera itself. Finally, it doubles your battery life when you're on a long shoot, because it holds two batteries, delivering up to 1,500 shots. It costs $249.99 and is available from www.sonystyle.com.

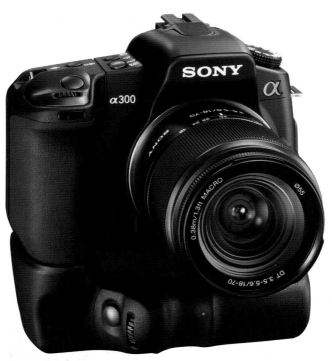

Mounted here on the A300, note the modified placement of the vertical shutter release, which makes both grip styles feel similar. The relationship between your right hand on the grip and your left on the lens is essentially in the same plane, regardless of which you hold.

Printer

Because the Sony A300 is capable of outputting good quality 13 × 19-inch prints, and even more if you shoot RAW, it's worth considering how you'll take advantage of all that ability. People who walk into my home are impressed with two things, and only two things: the cleanliness of the place (thanks primarily to my wife), and the large photographs of our family on the wall. Each photograph, ranging from 8 × 10 to 13 × 19 inches, was printed in my home on a large-format printer.

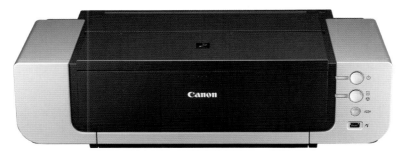

Canon Pro9000.

Currently my printer is a Canon Pro9000, a high-quality yet afford-able printer that is fast and quiet. It is where my best photos are properly honored. The Pro9000 uses eight inks and is currently available for just over $400.

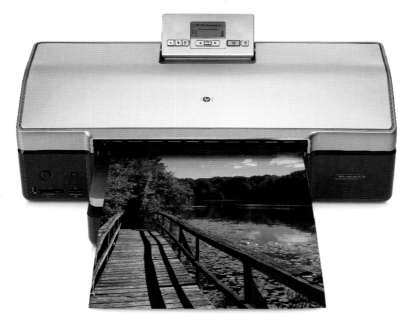

HP Photosmart 8750.

You should also consider the HP Photosmart 8750 Large-Format Professional Photo Printer, which is available at a street price similar to the Pro9000 (between $400 and $450).

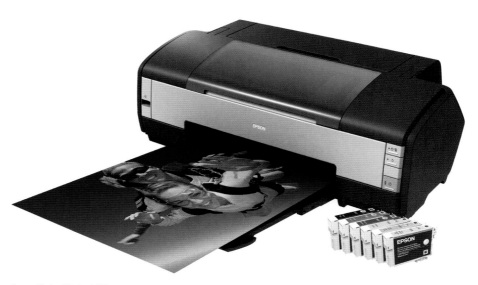

Epson Stylus Photo 1400.

Though it's a little slower, the Epson Stylus Photo 1400 offers the same size printing at a lower price of under $300.

If you'd rather leave the large printing to your photo lab, consider just about any letter-size photo printer from any of the three brands just mentioned for your home printing. The letter-size models change almost quarterly, so recommending a specific model would not be helpful. Prepare to pay from $100 to $150 for good photo quality, and stick to the manufacturer's paper and ink supply. I've blown too much money buying quality third-party paper and found that the results weren't up to the standard I expect. Part of the problem is the manufacturer locking you into their supplies, some of it is the manufacturer matching their ink and paper technology to their printer's best abilities, and some of it is the third-party paper and ink makers' inability to match a universal paper and ink specifications to several different printer models. Whatever the reason, to maintain better print quality it's worthwhile to match the paper and ink to the printer. If you buy from reputable retailers online, you can get good deals.

ADI flash metering

Stands for Advanced Distance Integration. A flash metering mode that integrates focus distance from the lens with Pre-flash TTL to set flash power.

Adobe RGB

A color space developed by Adobe Systems that includes more colors than sRGB to work better with CMYK printers.

AF

Autofocus; the system in a camera that uses phase detection or contrast detection to bring a lens to focus on a subject.

Aperture

The adjustable lens setting that regulates the amount of light that enters a lens. It works much like the iris of an eye, getting larger and smaller to let more or less light in. Maximum aperture is the most light a lens allows through the lens.

Available light

Light that doesn't require special photographic equipment to generate.

Backlight

Light that comes from behind the subject. This light can often cause underexposure of the subject, due to the light overload from behind. Lens flare is also a danger with backlight.

Backup

Saving a second copy of your images in case of hard drive failure or accidental erasure.

Bracketing

Taking two additional photographs after the proper exposure that are slightly under- and overexposed to guard against exposure error.

Bulb

A shutter setting that allows you to keep the shutter open as long as you hold the shutter button down. Best used with a remote shutter release to reduce vibration.

Card reader

An optional accessory that plugs into your computer and reads memory cards. They are usually faster than the camera's USB interface.

CMYK

CMYK is a subtractive color model that stands for Cyan, Magenta, Yellow, and Key, or Black. It is used in printing houses, as well as in most computer printers. An RGB combination produces white; the combination of CMYK produces black.

CompactFlash (CF) card

A memory card standard that uses flash memory with a 50-pin interface. Comes in two sizes, dubbed Type I and Type II.

Contrast

The degree of difference in color and brightness between tones in an image.

Depth of field

The area in front of and behind a focus plane that is as sharply focused as the actual plane of focus.

Dynamic Range Optimization (DRO)

Sony's own system, designed to analyze an image and make sure that highlights and shadows are not over- or underexposed.

Exposure value (EV)

The calculated combination of aperture and shutter speed necessary to expose an image properly. The term is usually used to refer to adjustments to what the camera's meter has determined is correct; that is, EV compensation.

Eye-start AF

A Sony system that uses two infrared sensors beneath the optical viewfinder to detect the user's face coming up to the camera. The camera then starts the autofocus system so that it's very often focused before the user is even able to see the entire view.

Flare

Stray light bouncing around in the lens causes lens flare. Flare usually occurs when the sun is in the frame, and also when sunlight is allowed to hit the front lens element.

Focal length

Focal length is the distance between the optical center of the lens and the film or sensor, expressed in millimeters.

F/stop

The numerical representation of lens speed. Smaller numbers, like f/2.0 are actually larger openings, and let in more light than larger numbers, like f/11. Each time you stop-down a lens by one full stop,

it lets in half the light. Full stops are f/1.4, f/2, f/2.8, f/4, f/5.6, f/8, f/11/f/16, f/22. Cameras can also usually specify one-third stops in-between full stops.

Histogram

A graph of the tonal values in an image. Toward the left, values are increasingly dark; to the right, brighter.

High-speed synchro (HSS)

Also called "Focal plane mode" on other cameras. Uses multiple pulses of light to illuminate the sensor evenly at higher shutter speeds. Above a certain shutter speed, the second shutter curtain follows the first so quickly that the shutter opening is only a slit that travels across the sensor, so a single burst of light would illuminate only part of the sensor. HSS works around this, so that in Aperture priority mode, you can still use fill light at wider apertures.

Hot shoe

A special mount on the top of the camera that both secures and electrically connects a flash to the camera.

Image buffer

A special memory space on the camera that holds captured images before they are written to the card. This extra space allows you to take follow-up shots without having to wait for the data to be written to the card. There is usually a limit to how many images the buffer can hold.

Image stabilization

A sophisticated electronic technology that detects camera movement and shakes either an element in the lens or the image sensor itself to compensate, resulting in less motion blur.

ISO

ISO stands for International Standards Organization, the body that established the current film speed rating system. When referencing film or a digital camera's sensitivity, it represents the available speeds of a film or sensor.

JPEG

Stands for Joint Photographic Experts Group, the body that created the JPEG photographic compression standard used in most digital cameras. Data captured from the sensor in RAW format is quickly interpreted and compressed into a JPEG image and then copied to the memory card. High compression can produce image errors or artifacts, so it's better to stick to low compression when saving images in JPEG mode.

Macro

A lens or mode intended to take close-up pictures.

Masher

A camera operator who just mashes down on the shutter release button without prefocusing.

Megabyte

Depending on the vendor, a megabyte is 1,000,000 bytes, or 1,024,000 bytes, or 1,048,576 bytes. Computers use the third measurement; memory vendors usually use the first.

Megapixel

One million pixels.

Memory card

A card that usually uses solid-state memory chips to store data. Memory cards can also use hard drives to store data, though these are usually called "microdrives."

Natural light

Light that occurs in our normal lives, including sunlight, lamps, computers, and so on. Light that does not come from photographic equipment designed to light a scene.

Noise

An error in the camera's interpretation of the light it has received. It can occur because of sensor heat, electronic interference from outside or inside the camera, a defect in the sensor itself, insufficient light at the sensor site, or a random error in the camera's image parsing program.

Panning

Following a moving subject by turning the camera. Using a slower shutter speed shows motion by blurring the background more than the subject.

Perspective

How an image's distance is perceived when viewed through different types of optics. Wide-angle lenses make distant objects look further away from foreground objects, and telephoto lenses make distant objects appear closer to foreground objects. Perspective is thus expanded or compressed.

Preflash

Preflash is used to gauge the proper exposure for an object; depending on the object's relative reflectivity, preflash systems can be fooled into over- or underexposing an image.

Prefocusing

Half-pressing the shutter release button to allow the camera to set focus before slowly squeezing the shutter the rest of the way.

Prime lens

A lens with a single focal length. These are usually sharper and have a wider aperture than most zoom lenses.

RAW

A dump of the sensor's data into a single file that can be used to form an image later on a computer. The benefit of shooting RAW format is that you can change camera settings image-by-image long after

capture; the camera would normally process and apply settings to each image captured before saving to the card.

RAW + JPEG

A separate mode that allows you to capture both a RAW image and a JPEG-compressed image. It can be useful when you're not sure whether you'll want to do heavy processing after capture.

Resolution

The amount of resolving power that a sensor or lens has. Higher resolution means that a system can capture more detail.

RGB

RGB stands for red, green, and blue. RGB is an additive color model in which these three colors are added together to create a number of colors. Added together at full strength, they produce white. RGB is used in computer monitors, projectors, televisions, and sensors that produce images for these media.

Shutter

The mechanism that opens and closes at high speed to expose the sensor to light.

Single-lens reflex (SLR)

A single-lens reflex system presents an image to the photographer through the same lens that will capture the image. The mechanism depends on a mirror to interrupt the light path and reflect it to the focusing screen above, where it passes through a pentaprism and the final viewfinder optic to reach the photographer's eye. Before the shutter opens, the mirror moves up and out of the way to let the light pass. Twin-lens reflex and rangefinder systems use two optics: one for the viewfinder and one for the imaging optic.

Standard lens

Usually a prime lens. Maintains the proper perspective in a scene, whereas wide-angle and telephoto lenses tend to distort perspective.

Super SteadyShot

See *Image stabilization*.

Through-The-Lens (TTL)

Refers to exposure or autofocus systems that make their settings through the main, imaging lens element, rather than a separate optic or externally mounted sensor.

USB

Stands for Universal Serial Bus; a computer connectivity standard that allows many peripherals to connect to a computer. USB is also used to connect cameras to printers for computer-less printing.

USEFUL LINKS

To help you find out more about photography and Sony digital SLRs, I've compiled this list of Web links. These are just a few sites that I know about; of course, there are many more.

ALPHA-RELATED SITES
GENERAL INFORMATION

AlphaMountWorls.com
www.alphamountworld.com

Dyxum.com
"Home of the Minolta/Alpha-mount dSLR photographer"
www.dyxum.com

Dynax Digital Forums
"For Owners of Konica Minolta or Sony DSLRs"
www.dynaxdigital.com

USING WIRELESS FLASH

Wireless flash article: an excellent resource for learning about the Alpha wireless flash system.
www.friedmanarchives.com/flash.htm

A Minolta/Sony Alpha Flash compendium
www.mhohner.de/sony-minolta/flashcomp.php

Imaging Resource: Wireless Flash for the Common Man
www.imaging-resource.com/ACCS/56H/56H.HTM

A Photographer's Sketch Book—Notes on Lighting
www.filmlessphotos.ca

EQUIPMENT REVIEWS

Imaging Resource
www.imaging-resource.com

SLRgear.com
www.slrgear.com

Digital Photography Review
www.dpreview.com

Camera Labs
www.cameralabs.com

Digital Camera Resource Page
www.dcresource.com

Steve's Digicams
www.steves-digicams.com/default.htm

PopPhoto.com
www.popphoto.com

Photography Review
www.photographyreview.com

EDUCATION

Imaging-Resource Web Photo School
ir.webphotoschool.com

Photoflex Lighting School
www.photoflexlightingschool.com

DIYPhotography.net: Photography and Studio Lighting
www.diyphotography.net

PopPhoto.com
www.popphoto.com/lighting/

GOOD READS/BLOGS

The Online Photographer
theonlinephotographer.typepad.com/the_online_photographer/blog_index.html

The Luminous Landscape
www.luminous-landscape.com

Strobist: Learn how to light
www.strobist.blogspot.com/2006/07/how-to-diy-10-macro-photo-studio.html

SOFTWARE

Adobe Photoshop
www.adobe.com/products/photoshop/family

ONLINE SERVICES AND STORAGE

Phanfare: Store and view your pictures and videos online
www.phanfare.com

Flickr: Join an online community of photographers
www.flickr.com

SmugMug: Share your photos online
www.smugmug.com

Picasa Web Albums: Share your photos online
picasa.google.com

Swiss Picture Bank
www.swisspicturebank.com

Index

A

AC adapter, 83
Accessories
 buying guidelines, 167
 flash, 169–174
Action shots
 lens selection, 161–162
 shooting, 162
ADI, *see* Advanced Distance Integration
Adobe RGB mode, Creative Style, 51
Advanced Distance Integration (ADI), flash
 metering, 171, 191
Advanced modes, 30–31
AEL button, *see* Auto Exposure Lock button
AF, *see* Autofocus
AF-A, *see* Automatic autofocus mode
AF-C, *see* Continuous autofocus mode
AF Illuminator setting, 64
AF Priority setting, 64
AF-S, *see* Single-shot autofocus mode
Aperture
 definition, 191
 principles, 13–14
Aperture Priority mode, 30
Aspect Ratio setting, 62
Audio signals option, 75
Auto Exposure Lock (AEL) button, 39–40, 55, 66
Auto flash mode, 54
Autofocus (AF)
 definition, 191
 operation
 areas, 41–42
 modes, 42
 quick start, 7–8, 10
 switch, 40
Automatic autofocus mode (AF-A), 42
Auto mode, 28
Auto Off W/VF setting, 67

Auto Review setting, 67
Auto White Balance (AWB), 10, 44, 45
Available light, 191
AWB, *see* Auto White Balance

B

Background, tips, 18
Backlight, 114, 191
Backup, 102, 191
Battery
 charging, 82–83
 compatibility, 81
 storage, 82
Battery grip, 185–186
Black and White mode, Creative Style, 52
Bounce flash, 109–110
Bracketing
 Continuous Bracketing mode, 36
 definition, 191
 exposures, 33–35
 Single Bracketing mode, 36
 White Balance Bracketing mode, 37
Bulb, 191

C

Candlelight, 108–109
Canon Pro9000 printer, 187
Card reader, 192
Card, *see* Memory card
Center-weighted metering mode, 38
CF card, *see* CompactFlash card
Charging, batteries, 82–83
Checklist, prior to shooting, 32
Children, *see* Kids and pets
Cleaning Mode, 76–77
Cleaning, camera and sensor, 83–85
Close-up lens, 141–142

Cloudy mode, 45
CMYK, 192
Color Filter mode, 46
Color space, setting, 44, 47–49
Color temperature, setting, 46
CompactFlash (CF) card, 76–77, 192
Composition, 17, 18
Continuous advance, 35
Continuous autofocus mode (AF-C), 42
Continuous Bracketing mode, 36
Contrast, 192
Control Dial Setup, 66
Conversion Factor, 123
Creative Style modes, 50–51, 63
Crop Factor, *see* Conversion Factor
Custom menu, 66–67
Custom white balance, 46

D

Date imprint, 70
Date/Time setup, 73–74
Daylight mode, 45
Deleting, images, 56–57, 68
Depth of field, 192
Digital Print Order Format (DPOF)
 principles, 59
 setup, 69–71
Direct Manual Focus, 43
DPOF, *see* Digital Print Order Format
Drive modes, 35–37
DRO, *see* Dynamic range optimization
Dynamic range optimization (DRO), 49–50, 192

E

Epson Stylus Photo 1400, 189
Erasing, images, 56–57, 68
EV, *see* Exposure value
Exposure value (EV)
 definition, 192
 setting, 32
Eye-start AF, 66, 192

F

File Number, 74
Fill-flash mode, 54

Fireworks, 159
Fisheye lens, 131
Flare, 192
Flash
 accessories, 172–173
 bounce flash, 109–110
 exposure compensation, 53
 limitations, 105
 metering options, 53
 modes, 54
 multi-flash, 110–111
 operation, 9, 54
Flash Compensation setting, 63–64
Flash control setting, 63
Flash mode, 54
Flash Off mode, 29, 54
Fluorescent mode, 46
Focal length, 192
Focal Length Multiplier, *see* Conversion
 Factor
Focus, *see* Autofocus
Folder Name, 74
Foreground, tips, 18
Formatting, memory card, 69
Framing, subjects, 26
F/stop, 192–193
Full Auto modes, 28–30
Function button, 6

G

Golden hour, 111–112
Gripping, camera, 15
Guide number, flash, 170, 171–172

H

High ISO Noise Reduction setting, 65
High-speed synchro (HSS), 193
Histogram
 definition, 193
 display modes, 57
 principles, 58
 portrait, 148
Holding, camera, 14
Hot shoe, 193
HP Photosmart 8750, 188
HSS, *see* High-speed synchro

I

Image buffer, 193
Image Data Converter SR, 92–97
Image Data Lightbox SR, 91–92
Image Size setting, 62
Image stabilization, 193, *see also* Super
 SteadyShot
Index print, 71
Information Display Time, 72
ISO
 definition, 193
 changing sensitivity, 31–32

J

JPEG, 195

K

Kids and pets
 lens selection, 152
 shooting, 152–153

L

Lamplight, 108
Landscape mode, 29, 51
Language, settings, 73
LCD brightness, adjustment, 72
Leading lines, 19
Lens
 close-up lens, 141–142
 prime lens, 127
 selection
 action shots, 161–163
 kids and pets, 151–153
 portraits, 145–149
 travel, 155–159
 Sony products, 125
 standard lens, 133–135
 telephoto lens, 137–139
 wide-angle lens, 129–131
 zoom lens, 126–127
Local autofocus area, 41–42
Long Exposure Nose Reduction
 setting, 65

M

Macro mode, 29, 142
Macro Ring Light, 173, 174
Macro Twin Flash Kit, 173
Manfrotto 3016 monopod, 180–181
Manfrotto Bogen 190XDB, 177–179
Manfrotto Bogen 728B Digi Compact Tripod,
 179–180
Manual exposure mode, 30–31
Manual focus, 40
Masher, 193
Megabyte, 194
Megapixel, 194
Memory card
 brands, 80
 care, 80
 definition, 194
 formatting, 69
 protection, 69
 readers, 81
 speeds, 80
 types, 79
Memory Stick Duo card, 79
Menus
 Custom menu, 66–67
 Playback menus, 67–72
 Recording menus, 61–65
 Setup menus, 72–77
Metering Modes, 37
Microdrive, 80
Mode dial, 6
Monopod, 180–181
Multi-flash, 110–111
Multi-segment metering mode, 38

N

Natural light
 definition, 194
 indoor light
 candlelight, 108–109
 lamplight, 108
 simulated window light, 107–108
 window light, 106–107
 outdoor light
 backlight, 114–115
 golden hour, 111–113

Natural light (*Continued*)
 outdoor light (*Continued*)
 overcast sky, 115
 shade, 117
New Folder, 75
Night photography, 116–117
Night View mode, Creative Style, 51
Night View/Night Portrait mode, 29–30
Noise, 194

O

Overcast sky, 115

P

Panning, 194
Perspective, 194
Pets, *see* Kids and pets
PictBridge, 59–60
Picture Motion Browser, 89–91
Playback controls, 9, 55
Playback menus
 Menu, 1, 67–71
 Menu, 2, 71–72
Portrait
 lens selection, 146
 overview, 145
 shooting, 146–149
 wide-angle shots, 10–11
Portrait mode, Creative Style, 29, 51
Power Save, 72
Power switch, 5
Preflash, 194
Preflight checklist, 32
Prefocusing, 16, 194
Prime lens, 126, 127, 194
Printers, 187–189
Printing, images, 59–60
Program mode, 30
ProMax system, 172
Protect option, 69

Q

Quality setting, 63
Quick start, 5–12

R

RAW, 194–195
RAW_JPEG, 195
RCA jack, 59, 73
Rear sync flash mode, 54
Recording menus
 Menu 1, 61–64
 Menu 2, 64–65
Record mode reset, 65
Red eye reduction, 67
Remote controller, 183
Reset Default, 77
Resolution, 195
RGB, 49, 195
Rule of thirds, 17

S

Select Folder, 75
Self-Timer, 35
Sensor, cleaning, 84–85
Setup menus
 Menu 1, 72–74
 Menu 2, 74–75
 Menu 3, 76–77
Shade, 117
Shade mode, 45
Shutter, 195
Shutter Priority mode, 30
Shutter release button, 7
Shutter speed, 13–14
Single Bracketing mode, 36
Single-lens reflex (SLR)
 definition, 195
 popularity of cameras, 4
Single-shot advance, 35
Single-shot autofocus mode (AF-S), 42
Slideshow mode, 56, 71–72
Slow sync flash mode, 54
SLR, *see* Single-lens reflex
Software
 bundles, 89
 Image Data Converter SR, 92–97
 Image Data Lightbox SR, 91–92
 Picture Motion Browser, 89–91
Sorting, images, 99

Sports mode, 29
Spot autofocus area, 41
Spot metering mode, 38–39
Standard lens, 133–135, 195
Standard mode, Creative Style, 51
Standing, shooting, 20
Sto-Fen Omni Bounce, 173
Storage
 batteries, 82
 images, 101–102
Sunset mode, 29, 51
Super SteadyShot
 definition, 195
 operation, 43

T

Telephoto lens, 137–139
Through-the-lens (TTL), 195
Timer, *see* Self-Timer
Travel
 lens selection, 156–157
 shooting, 157–158
Tripod
 feet, 176
 heads, 176–177
 height, 176
 recommendations, 177–180
 weight and construction, 175–176
Trips, *see* Travel
TTL, *see* Through-the-lens
Tungsten mode, 45

U

USB, 75, 195
Use Connection, 75

V

Vacation, *see* Travel
Video output, 55, 72–73
Vivid mode, Creative Style, 51

W

White balance
 Auto White Balance, 10, 44, 45
 modes, 45–47
 overview, 44
 setting, 44–47
White Balance Bracketing mode, 37
Wide-angle lens, 129–131
Wide autofocus area, 41
Window light, 106–107
Wireless flash control, 54

Z

Zoom lens, 126–127
Zoom ring, 7, 8, 9

Focal Press

Monthly Photography Contest

The Focal Press Monthly Photography Contest is open to everyone. Each month has a different theme, ranging from black and white photography to wedding and nature photography. Monthly prizes and bi-annual grand prizes are awarded. There is an online voting system and guest judges from among Focal authors and the Focal editorial team.

Focal Press